Dwelling

in

Possibility

Priscilla Wilson

Mt Yonah Press

For Information: Mt. Yonah Press, 2319 Duncan Bridge Road, Sautee, GA 30571

ISBN: 978-0-692-85561-4

Table of Contents

Unless otherwise noted, these essays appeared in the *White County News,* Cleveland, Georgia, between 1986 and 2015.

For their wisdom, help, and generosity,
my thanks and admiration go to

Billy Chism
Linda Crittenden
Elsa Ann Gaines
Janice Lymburner
Carol Majors
Mildred Neville
Barbara Williams
Sam Williams
and to the memory of Emily Dickinson

The essays in this collection are dedicated to
these people and to all kindred spirits, readers
and thinkers who celebrate this life by trying
to figure things out.

I dwell in Possibility –
A fairer House than Prose –
More numerous of Windows –
Superior – for Doors –

Of Chambers as the Cedars –
Impregnable of eye –
And for an everlasting Roof
The Gambrels of the Sky –

Of Visitors – the fairest –
For Occupation – This –
The spreading wide my narrow Hands
To gather Paradise –

–Emily Dickinson

Thinking

Dwelling in Possibility

Written for this collection in July, 2016

As I see it, nineteenth century American poet Emily Dickinson wrote one of the most profound lines in all of literature: *I dwell in Possibility.* This simple phrase is my theme song, my comfort, the sermon I preach to myself. It happens to be the first line of a poem but could have been part of a treatise on history or quantum physics or theology.

The history connection is easily understood; one can almost hear Dickinson's line echoing through time. The story of our universe is one long illustration of possibility, from the big bang to the first appearance of life on earth to evolution—and finally to the ongoing stream of seemingly impossible human ideas and inventions. All of history has been and continues to be about possibility.

The quantum physics component requires a little more explanation. I don't suppose Einstein would have accepted Dickinson's words as the theory of everything that he sought and physicists still seek—the theory that

1

unifies the microcosmic, or subatomic, world with the macrocosmic world we humans know firsthand. For us laypeople, however, it may very well do the job.

Modern physicists tell us that so-called subatomic particles are actually *possibility waves*. The commonly used term *particle*, they explain, can be misleading in that it implies an object which is solid, real, and predictable. Conversely, subatomic particles *blink in and out of existence*—and in and out of transactions with other entities. Thus the very fabric of the universe, often described as the quantum field, is perpetually knitting itself from possibility. We truly *dwell in possibility* in a physical sense.

In the macrocosmic world, the everyday world that mostly makes sense to us, we also dwell in possibility, though in a more figurative way. It isn't always easy to celebrate or be philosophical about the fact that we're as likely to fall victim to a crashing asteroid as to spot a large diamond in the grocery store parking lot. And yet it is possibility that keeps us hooked on life. People with no apparent reason to get up every morning do so because of possibility, or the knowledge that anything can happen. We don't always know *what* we hope will happen, but we're curious enough to stick around.

So as the key to the functioning of both our everyday world and of the subatomic world, possibility is indeed the unifying concept for which physicists have

been searching. If only Dickinson could be here to claim the Nobel Prize in Physics she so richly deserves.

Finally—and in ways that for some of us are inseparable from the quantum physics component—"I dwell in Possibility" is a theological statement. For me, Possibility with a capital *P* is another name for God. All human beings desire to be part of this Creative Force which is "making all things new," as the Apostle John expresses it in the Book of Revelation. Like some who believe in more traditional theologies, I want to proselytize, to shout from the rooftops: I owe my life and happiness to this mystical Force which permeates my being and quickens my spirit.

The experience of creating—of grasping new ideas and attempting to share them or bring them into tangible form—makes me feel connected to Possibility like nothing else. It makes me feel as though my every cell is singing, vibrating with energy and the will to live. It's no wonder that, as an artist and writer, I'm always longing for the next such encounter.

However, in no way do artists do have a corner on creativity; Possibility manifests through people in all walks of life. Each of us is responsible for the ultimate creation, that of our own life—and for continually welcoming the movement of the Divine, however we perceive it, in us.

I hope the essays in this collection are some small evidence of my experiences of dwelling in Possibility.

3

Life Challenges

When I wrote the first version of this, I was 35 or so and just getting my bearings as an adult. It still rings true for me.

My kindergarten teacher told me that I would really have to buckle down in first grade. "Next year," she said, "the challenge will begin in earnest"—or something to that effect.

If I'm not mistaken, my first grade teacher said pretty much the same thing about second grade and so on down the line. It seldom if ever happened for some of us; the real challenges, the tasks we could sink our teeth into, didn't present themselves.

Before junior high—and then high school—the adults laid it on thick. "You've had it easy so far," their voices still echo down the years, "but high school is going to be tough. You're going to have to reach deep inside yourselves and call on all your inner resources." Yeah, right.

Part of me stopped expecting the exciting opportunities that were promised, as evidenced by a painful experience in ninth grade. On the first day of school, Emily Anderson, our young and pretty Civics teacher, asked each of us to write an autobiography in class; on the second day, after returning our papers to us, she offered to "analyze," based on our personal stories, those who wanted to stay after class.

When my turn came and Ms. Anderson glanced back over my paper, she casually delivered a stunning

indictment: "You are bored with life." I'm not sure what else, if anything, she said. She may have explained that I'd described my life as ordinary and predictable—or maybe I figured that out for myself. I do remember later poring over the paper, trying to fathom her pronouncement and determine whether I was guilty as charged.

Looking back, I understand that the answer was mostly *yes*. *Yes*, my short life had sounded—and had been—ordinary up to that point. *Yes*, I was bored as charged. I had, after all, endured eight years in school of agonizing repetitive exercises performed in writing and aloud, eight years with little schoolwork that excited me. I had sounded bored in the paper both because I *was* bored and because I didn't quite realize it. It was what I knew.

But now—now I want to share my joy and amazement that finally, in adulthood, the boredom has ended: The challenge is here, and it is enough. No matter how capable a person is—or how happy and well-matched with their job, family, and friends—life is demanding. How can we possibly manage all the tasks assigned to us by ourselves and others?

Some people are able to keep physically fit and study their insurance policies and spend time with their families. Others read *The New York Times Book Review* and put healthy food into their bodies and remember to send birthday cards to all their friends. Still others find

time for flossing their teeth twice a day and giving parties and having their tires rotated regularly. But can anyone do all these things, go to work every day, and have an inner life to boot?

We're definitely talking difficulty and challenge here. And we're only talking about basic life management. The *real* demands—the individual tasks, projects, and goals we adopt because they have special meaning for us—have to fit in somewhere. I don't foresee running out of challenges in my lifetime.

The reason these observations matter to me is this: Having been conditioned not to expect challenge, I need to remind myself periodically that the big moment, the occasion for all-out effort, is here. It is not just around the corner, like they told us in school. It is finally here, and it is cause for celebration.

One of God's Names Is Murphy

I gave a version of this piece as a talk at the Georgia Mountains Unitarian Universalist Church in 2002.

One of God's names is Murphy—as in Murphy's Law. When I'm feeling upbeat enough to be philosophical about "Ol' Murph," as my father used to call him, I genuinely believe that he can serve a divine purpose in human lives.

The famous law is usually worded this way: *Anything that CAN go wrong, WILL go wrong.* A quick internet search for the phrase "Murphy's Law" yielded 441,000 hits. Scores of armchair philosophers, in an effort to find humor in this all-important law, have attempted to articulate it in different ways and break it down into sub-categories such as Murphy's laws of love, copy machines, cell phones, and so on. The possibilities are infinite.

But what of the connection between Murphy and God? When you think about it, Murphy can be described by the very same adjectives for God that we learned in Sunday School: *omniscient, omnipresent,* and *omnipotent.* And, like the traditional god, Murphy has powerful gifts for us when we make a spiritual practice of relating to him. His way of teaching us is by throwing misfortunes our way.

There are profound words in world literature about the lessons of adversity. From Buddha, we have:

"To my best disciples I give disease, poverty, and dishonor." Rumi wrote: "Do not complain of affliction ... for it is a smooth-paced horse carrying you towards truth." And Rev. Dr. Martin Luther King, Jr. often spoke of the "redemptive value of suffering." Most famously, Jesus said, "Blessed are the poor in spirit."

But I want to make a serious distinction at this point about the relatively low level of adversity we're talking about here. In my opinion, the serious tragedies in life—a cancer diagnosis, the loss of a job, the end of a marriage—are not caused by Murphy or any other god. My purpose is not to make light of real misfortunes or add to the stack of platitudes about God working in mysterious ways. Instead I'd like to point out some ways in which Murphy can be a spiritual guide for regular people dealing with day-to-day misfortunes.

First, Murphy reminds us that matter doesn't matter. When you think about it, most of his shenanigans have to do with material things: toggle bolts, computer printers, car tires, alarm clocks, stains on new clothing, burned toast, and so on. This annoying teacher shows us continually that, if we put too much energy into *stuff*—into the material world as opposed to the spiritual one—we'll always be disappointed.

Another message, one I especially need to embrace, is about living carefully and consciously in the moment. When I hurry—thus failing to stay in the

present—Murphy finds ways to sit me down and point a finger at me. He causes me to lose keys, pocketbook, or glasses at every turn. I tell myself that my mind is in lofty places, but the truth is that there's no loftier place than the present.

Likewise, Murphy reminds us not to take ourselves too seriously. Start feeling proud of yourself for some reason, and that's when you'll come out of a public restroom with toilet paper hanging out of your clothes. And I can't help thinking of dear President Gerald Ford, the most powerful man in the world in 1975, falling down on the tarmac for no apparent reason except that You-Know-Who was his teacher.

Finally, I believe Murphy's central lesson is that joy and meaning are found, not by dodging or resisting life's difficulties, but by expecting and welcoming them —that is, by accepting Murphy's presence and trying to see each problem as a gift. Yes, easier said than done.

But Murphy is with us, and we might as well make our interactions with him a spiritual practice. Whatever else he is, this force which seems so bent on vexing and challenging us—he is the giver of profound opportunities for spiritual growth.

On Yonah

The Monument in our Midst

Sometimes when I look toward the mountains in the northern part of White County, Georgia and beyond, I have to admit that my neighbor, Mt. Yonah, isn't exactly spectacular; yet I feel intensely loyal to this rather small mountain that stands near the center of our county, alone except for its little sidekick known as Pink Mountain.

Yonah, meaning "bear" in the language of the Cherokees, stands just 3,156 feet above sea level. On a topography map, one can easily find several higher mountains close by: Tray, Cowrock, and Horse Range, to name a few.

The elevation of Brasstown Bald in Towns County is 4,784; and North Carolina's Mount Mitchell, the highest peak in the Appalachian chain, stands 6,711 feet high—more than *twice* the height of our Yonah.

People who live in the "real" mountains see dramatic views of giant purple peaks stretching into the distance, layer upon layer, until the human eye can't distinguish land from sky. But to me those mountains seem generic, impersonal, and mostly indistinguishable

from one another. I've been told the names of some of them, but they don't usually stay with me.

I do not think anyone ever forgets Yonah's name. It's a mountain with character, a mountain people can focus on and get to know. It dominates the southern half of our county, gently demanding that we acknowledge its presence and try to fathom its mysteries.

The rock which was to make up much of Yonah began forming no less than 500 million years ago. Yonah itself, along with the whole southern Appalachian chain, was formed some 270-300 million years ago when glaciers moved through our continent at the end of the Paleozoic period.

We'll never know just how Yonah looked 270 million years ago or how much larger it was then than now. We do know that it has been right here for an incomprehensible number of years and that the very rocks we now see on Yonah have been here since before its formation.

Our own Yonah witnessed the advent and extinction of primitive plant life and of dinosaurs. It hosted the first birds and early flowering plants 100-200 million years ago.

It was home and refuge to the first grazing mammals perhaps 25 million years ago. And, finally, Yonah saw humans enter the local scene—in all likelihood, only a few hundred thousand years ago. We're newcomers.

It's no wonder we're fascinated by a mountain such as Yonah which is so accessible to us. We have at our fingertips a masterpiece of sculpture, created by forces we can't begin to comprehend.

Yonah is a monument—to change and changelessness, to the mysterious forces this mountain has witnessed, and, for those who live in its shadow, to the history of our particular home on Planet Earth.

Spring on Yonah

I wrote this column when I was in my mid-thirties; funny,
I thought I was aging. Now that I really am aging, these words
reawaken a feeling that, at 66, I crave.

I'm sitting on a rock about one third of the way
up Yonah Mountain—actually in the "crease" between
Yonah and its little sidekick, Pink Mountain—as I write.
This trek has become a ritual for me, a way of greeting
the spring each year and seeing up close the evidence of
its arrival.

Sure enough, the evidence abounds. From the
pasture below me, I didn't see very much green on the
mountain; it's a little too early for that. But from where I
now sit, I am reassured by the sight of life spurting from
the tip of most every branch. Equally reassuring are the
sights and sounds of life-renewing water, tumbling and
sliding and heaving its way down the mountainside,
playing its essential part in resurrection every inch of
the way.

There are springs everywhere up here, and this is
their season. Beautiful words—spring and *spring.* I
wonder: Are those two meanings represented by the
same word in other languages as they are in ours? I hope
so.

Green shoots are pushing their way through the
ground, crinkled and misshapen like newborn babies,
opening up and stretching almost before my eyes. The
acorns scattered on top of the ground look just like they

did a few months ago except that, unseen by the casual observer, some miraculously have taken root and are aiming to be trees someday.

And brand new ferns are curled up all along the creek banks like so many caterpillars waiting to become butterflies. Strange yet heartening mysteries surround me.

I needed to see evidence of new life inside myself as well as outside, and this hike has been reassuring in that way. When I'm up on this mountain, I become a child again—jumping from boulder to boulder, lying on my stomach to drink from a spring, fantasizing about caves and secret Indian hiding places among the rocks.

"There's life in the aging girl yet," I tell myself with joy and relief as I start back down the mountain.

Coming to Terms

I begin my autumn trek up Yonah Mountain with great anticipation. I've felt the mountain tugging at me for days, and my expectations are high. Whatever it is I will see and hear this afternoon will bring nourishment.

Unexpectedly, I imagine copperheads sunning themselves on some large rocks near the trail and begin to feel a little fearful. They'll be sluggish, I reassure myself. I think of how animals hibernate by degrees and remember how, as a child, I thought that hibernation was an all-or-nothing proposition. Now I understand that most changes happen gradually.

I'm gawking at several electric-blue bottle gentians beside a creek when the sound of a gunshot in the distance brings more fearful thoughts. What are the chances, I wonder, of a hunter's bullet finding me? Feeling some irritation with the unseen hunter for giving me reason to be afraid—and with myself for letting fear have the upper hand—I continue walking upward.

There is a deafening rattle of leaves, and a doe runs right in front of me. She is being pursued by two dogs, but she easily outdistances them. I look and listen for a long moment, but all is quiet again except for the soothing sound of falling leaves.

Continuing my climb, I eventually become caught up in my surroundings and forget about fear. I collect leaves the way one might collect shells on the

beach: an iridescent orange one no larger than my thumbnail; a green maple leaf with a single dime-sized red spot; a huge white oak leaf in a sublime shade of burgundy; and a leaf I can't identify that is solid color-crayon red.

I notice the changes that have taken place since my spring visit to these woods, much as I would notice changes in the home of an old friend. Abundant fallen leaves have softened the lines of the massive rock furniture arranged in homey clusters here and there, creating a warm and mellow ambiance that wasn't here last spring. More leaves provide a multicolored carpet that is crispy-plush, covering even the creeks that were such focal points a few months ago.

Lying on my back on a big rock in the sun, I notice how loud the sound of falling leaves can be when there's no other sound. I watch five turkey buzzards overhead looking for a carcass and sit up quickly so they won't mistake me for dead meat.

Starting down the mountain, I think again of my earlier fears and note that I've seen neither copperheads nor flying bullets. Then I think of the fleeing deer and the fact that its kind lives with real danger all the time.

Every living creature faces dangers, both real and imagined, that point to the same thing: extinction. But right now, in this season of comfortable, transitory death, I can learn something about living with the awareness of endings to come.

New Beginnings

I wrote this piece soon after the death of my beloved grandmother, Mae Mae, in March of 1991.

I should have known better, after living for fourteen years at the foot of Yonah, than to go up on the mountain so early searching for spring. But the peepers had been loud the last few nights; the bloodroot, trailing arbutus, and even rue anemone were blooming; and I needed to write about new beginnings.

I expected to find inspiration on the mountain. Instead I found, still painfully exposed, the wreckage of an unusually violent winter: newly-fallen trees, strewn through the lifeless woods like dead soldiers on a battlefield or pieces in a giant game of Pick-up-Sticks. There were stretches along my accustomed path where I couldn't walk more than a few steps without climbing over a corpse.

We're not talking about young, shallow-rooted pines here, but trees with character—deep-rooted oaks, poplars, and maples. Some had obviously been struck down in their primes during recent storms; others had lived out their natural life spans and fallen only after their deaths were accomplished.

They were not, of course, all victims of the winter just passed—though quite a few were. Still, the effect of seeing such a large accumulation of life's casualties at once was painful.

After my eyes became accustomed to the devastation, however, I began to see the beauty as well as the tragedies of these fallen beings. Because they were on the ground right in front of me, I could now admire their stature, the artfulness of their growth patterns, and even some of their root systems in a way I had been unable to do before.

These seemingly dead beings will continue to exert their influence; they will continue to be quite literally a part of life for a long time to come, setting the stage for growth to go on around them. In time, they will provide nourishment for other life forms.

In a month, the lines of these fallen trees which today looked so strange and stark, will be softened and embellished by the growth of plant life on and around them. I can predict with certainty that the next time I walk on the mountain, my eyes will not single out victims but see life there as the amazing whole that it is.

So I found my inspiration after all. I was reminded that new beginnings happen, not in spite of the losses we suffer, but because of them and in accordance with them. Spring is a new beginning that can and must be celebrated even amidst the wreckage of winters past.

Life-giving Waters
River of Ice

This piece was written in the 1990s. I didn't name the friend whose memory is described, because I wanted to honor his privacy. I happened to see his daughter in 2016 and told her of my plans to use the story in this collection. She had not heard the story. Her father has Alzheimer's and wouldn't be able to tell it now.

A friend of mine gave me a considerable gift the other day. It was the gift of an important memory of his —a powerful image and a part of himself. We were talking lightheartedly about ice and snow when my friend suddenly was flooded with a memory as crystal clear as any winter night, one I suspect he hadn't thought about for a long time.

It was a memory of another time and place, a story about a north Georgia farm boy turned infantryman who was sent to Korea in the early 1950s. On the night my friend described, his battalion was fleeing south from the border between North Korea and China. Leaders had been alerted that invading Chinese outnumbered Americans fifty to one, and the march toward safety had begun in the middle of the night.

The temperature was ten degrees below zero. The

only light came from the snow and from the moon when the clouds uncovered it from time to time. All was quiet except for the sound of boots crunching and squeaking in the snow.

It was 2:00 a.m. when the group of young men came upon a river which, they realized all too quickly, would have to be crossed if they were to continue making southward progress toward safety.

The river appeared to be frozen, but it was deep and wide. Was it safe to walk across the river? Was it safe to do otherwise?

The captain chose a bend in the river where the current should have been slowest and therefore the ice should have been thickest. But the river was very wide there, perhaps a hundred yards.

He instructed the first squad, my friend's squad, to begin walking across and to hold their guns out in front of them to help break their falls if necessary.

My friend was on the front line in the battle of nerves that followed. "It was so quiet," he remembered. "Nothing was stirring, not even a little breeze. It was so quiet on that ice you could have heard a pin drop."

And then the eerie sound of cracking ice rang out. The men could hear the metallic sound move across the river; then all was quiet again. The ice did not give way. The men did the only thing they could do: they continued, practically holding their collective breath with fear and the effort not to put stress on the ice.

Every man in the battalion made it across the ice. They were glad to be alive on that cold, cold night in that strange land.

"I'll never forget that night as long as I live," he concluded with tears in his eyes. I knew I wouldn't forget either.

My friend had created through the miracle of human communication one of those rare moments when times and places and minds converge in a flash of understanding as beautiful and fragile as a river of ice.

A Sight for Thirsty Eyes

As we left Orlando behind and headed down the turnpike toward Ft. Lauderdale, I idly studied the Florida page in my trusty road atlas. My eyes landed on the huge inland lake called Okeechobee.

"I wonder if any human being has actually *seen* Lake Okeechobee," I joked. I'd seen it on maps many times but had never been there or heard of anyone who had. The lake, which appeared to be thirty or forty miles long and almost as wide, was situated just above those watery lines on the map that represent the Everglades. Its mystery and remoteness beckoned me.

Janice, my life partner and the driver on duty, had that worried look she gets when I study maps. Geography has never been her favorite subject, and she's uncomfortable being in the same *room* with a road atlas, let alone the same car. She knew I was about to suggest an alternate route or an educational side trip.

Her fears were well-founded. I had spotted an alternate route that would take us away from the boring turnpike, along the shores of Lake Okeechobee, and back to the coast just north of Ft. Lauderdale. We would easily make it to her grandfather's place in Pompano Beach on schedule, I told her, trying to sound confident.

As we exited the turnpike at Yeehaw Junction and turned onto U.S. Highway 441, I told Janice that in 25 miles we'd be able to number ourselves among the

few who could say whether there was indeed a real Lake Okeechobee or whether early map-makers had just painted it on the Florida map as a joke and never been questioned.

We hadn't gone three miles before I began to doubt the wisdom of my impulse. We had traded the surreal but safe world of the turnpike for the hard realities of hot, dry south Florida ranching country. Bony cows huddled listlessly under makeshift shadecloth tents, too hot to be interested in eating the brown grass surrounding them. An occasional pickup bouncing down a sandy farm road stirred up dust we could just about taste, even in our air-conditioned car.

That fearful being who lives inside my head began to show me pictures of the car breaking down and of our falling victim to the dry heat. Inward and outward scenery alike struck a sharp contrast to my earlier mental picture of the gigantic watering hole we were approaching.

At last we found ourselves riding along the eastern perimeter of the lake, and the environment gradually changed to a damp and shady one. There was only one problem: we couldn't even see the lake to our right, which seemed to be contained by a huge earthen dyke. The dyke appeared to be much higher than the road and, as far as we could tell, surrounded the lake. I began to wonder if there had been some truth in my joke about few people having seen Okeechobee.

For miles and miles we drove alongside the dam, straining unsuccessfully all the while to get just a glimpse of the lake. The saddest part was that there were cozy, albeit damp little trailer parks—the kind where retirees live in funky homes with brightly colored trim and pink flamingos in the yards—all along the highway, almost in the shadow of the grassy wall.

I didn't see how anyone, especially a retiree, could scale the 75 degree hill that separated these homes from the mythical lake. I couldn't get over the fact that folks lived just below such a natural wonder and never saw it, never feasted their eyes on that vast expanse of life-giving water. I figured they barely thought about the unseen body of water, that thirst-quencher for eyes and souls just over the hill.

And then I saw in a flash that most of us are like those residents—living in our own tiny worlds, right at the edge of vast, uncharted spiritual realms of which we're only dimly aware. Our minds' eyes shift back and forth between our physical realities—heat or dust or dampness—and those picture shows in our minds whose themes usually have to do with hopes and fears relating to those physical realities. Meanwhile, we forget about the spiritual dimension that can put our hopes and fears in perspective.

Most of us do get glimpses of our own personal Lake Okeechobees from time to time, just as Janice and I finally got to glimpse the one on the map. After some

30 miles of driving alongside the dam, we ascended a bridge that crossed a connecting canal and afforded us a view of the elusive lake.

It was a fine sight for thirsty eyes. And I vowed to intensify my personal efforts to climb dams, build bridges, or do whatever it might take to transcend barriers and enter the spiritual sea that beckons me to kick off my dusty shoes and swim.

Observations of a Night Intruder

Part of me didn't feel good about intruding on my summertime neighbors the other night, but I did it anyway. I went to the little pond near my house to spy and eavesdrop on its inhabitants.

For some reason I had been feeling drawn to this foreign night world, a noisy, dark, and eerie world that coexists with my usual night world of books and television and quiet diversions. So I waited until it was dark and the bullfrogs had begun their songs in earnest. Then I set out for the pond, equipped with mosquito repellent and flashlight.

As I drew near the pond, the sounds of the concert in progress became louder and louder. Most impressive were the resonant voices of the bullfrogs heard in living stereo. Sometimes they bellowed out solo parts, sometimes duets and trios; sometimes they sang in full chorus with voices coming from all sides of the pond.

It hit me that, though I thoroughly enjoyed the music, I couldn't begin to comprehend its mechanics or its meanings and subtleties.

And the castanets! I don't know what else to call them, because I never found the creatures making the sounds. Periodically, as if on cue, mysterious clicking sounds filled the air. I was standing so close to one clicker that the noise hurt my ears and felt like it went

right through me; but no creature with tiny castanets could I find.

Whatever else they were, the clickers were an excellent rhythm section and created an exotic, eerie atmosphere, like background sounds in a suspense movie. Occasionally, when the castanets were quiet, I could hear the haunting solo voice of a whippoorwill in the distance.

I began shining my flashlight along the edge of the pond, feeling guilty about disturbing the creatures that my light found; but I couldn't or wouldn't stop.

The head of a turtle or snake—I couldn't tell which—poked above the water line, and we stared at each other for a long moment. Its tongue darted out at me, giving and gathering information: Now I knew it was a snake, and it knew it wanted no part of me. We both moved on.

Next my light found tadpoles that had been cute in the daylight two weeks ago but now looked like little monsters lying in the mud. A few minnows in clearer water nearby hung motionless. Were they sleeping, and had my light awakened them? I had no way of knowing.

Here and there frogs of various sizes sat very still in the shallow water as if meditating. Their eyes were wide open, and they appeared to return my gaze. Were they among the musicians I had been hearing? Again, I couldn't know.

The steam rising from the water, the masses of

dark algae floating in places, and a certain heavy smell that hung in the air put me in mind of a huge, mysterious cauldron where life itself was being brewed. I thought of the thousands of micro-organisms in each drop of water and of the amazing concentration of life and energy around me.

Abandoning the role of intruder, I turned off my light and sat down on the ground, very still. As the concert continued, I witnessed a spectacular show being staged by lightning bugs against a backdrop of pines across the pond.

By the time I left to re-enter my indoor world, the lightning bugs were so high that it was hard to tell them from the twinkling stars; but what did it matter? Beauty is beauty, and it comes in a million mysterious forms.

Gourdzilla the Sea Serpent

This is an excerpt from my memoir, Gourd Girls.

In the spring of 1989, Janice and I heard about an upcoming Fourth of July river parade in Helen, Georgia. Anyone who wanted to decorate inner tubes or other floats could enter the parade. The storied Chattahoochee River, which originates near the Appalachian Trail in extreme northern White County, runs right through Helen.

I had always wanted an excuse to make a gourd raft. Besides, Janice and I had just seen the movie *Dead Poets' Society*, the theme of which was *carpe diem*, or "seize the day." What better way to seize the day than to make a gourd raft and ride it in a river parade? Janice was willing to be my support crew but didn't care to be in the parade.

Never was there any question in my mind about whether I could succeed in making a floating gourd vehicle. My main concern was that the water level might be too low in mid-summer for me to have a good ride. Putting that worry aside, I set about choosing the best method of gourd raft construction.

Deep down inside, I knew that the gourds needed to be contained in a net; but using a net seemed a little like cheating. Determined as usual to do things the hard way, I decided to make a pioneer, bare-gourd kind of raft. We had on hand a dozen long, slender gourds about

the size of baseball bats that I lashed together, Huck Finn style, as though they were logs. It was a beautiful raft, but I thought it wise to make a second prototype before going to the river for test rides. Raft number two consisted of nine roundish gourds about eight inches in diameter—three rows of three—connected with hooks and screw eyes.

At 7:00 on a blackberry winter morning in May, Janice and I took the two rafts to Helen for a trial run on the river. I knew the water would be frigid that early in the morning but didn't want to be seen making a fool of myself while trying to seize the day. My hope was that no one would be out that early.

Two inches of rain had fallen the day before, and the river looked much deeper and swifter than I had anticipated. Janice and I stood on the bank holding the Huck Finn raft, the length of which was almost my height, and tried to figure out how to get me into the water with it. Finally I just threw myself headlong into the river while holding the raft to the front of me. The raft fell apart the second it hit the water. Gourds went everywhere, and I sank into an icy, gurgling chaos. I managed to gain my footing in time to recover some of the free-floating gourds and throw them onto the river-bank. Janice helped me out of the river and wrapped a big towel around my goose-pimpled, shivering body.

We found a shallow spot a short distance upstream from which to launch the second raft. I eased

it into the current and lay down on it. Although the boat was anything but comfortable, it worked surprisingly well at first, taking me for a thrilling ride of some 25 yards before falling apart in a small rapid. Not surprisingly, the hooks and eyes pulled out of the gourds under the pressure of swiftly moving water. I was cold and discouraged, but those brief moments of success made me want to try again.

That afternoon I went to the hardware store in search of a net. My attempt to explain the raft project to the clerks was embarrassing; but this wasn't the first time they'd tried to help me with strange projects. The store didn't sell netting as such, but one creative clerk had the idea of using a nylon net hammock. I took one home, bagged up about twenty gourds in it, tied it securely, and tried to believe that raft number three would work. It was as big as a washing machine.

Meanwhile, another idea had come to mind that was elegant in its simplicity. Instead of making a complicated raft, why not just *ride on one gourd*, the largest gourd we owned? Maybe I had been making the task more difficult than it needed to be. Our champion gourd, bigger than a bushel basket, was roughly pear-shaped and as broad at its widest point as the back of a horse. I couldn't wait to ride it.

Back to the raging, frigid river we went, again early in the morning. This time, we took the hammock raft, the bushel gourd, and, at Janice's suggestion, a life

preserver. We'd both realized after the first test rides that I could have lost an entire lifetime trying to seize one day. I put the big gourd in the water first and struggled to mount my horse, which turned out to be a cross between a bucking bronco and a greased pig. The gourd would have held me up easily had I only been able to stay on it.

Janice finally stopped laughing long enough to hoist the bronco out of the water and hand me the huge hammock raft. It was even harder to mount. Finally, I heaved myself on stomach first and went for a short, uncomfortable ride with the unwieldy package of gourds getting wedged between rocks every few feet.

The date of the parade was getting closer. It was time to get serious about making a boat that would take me the distance sitting upright. I bought an additional hammock and did the job right, this time encasing a row of six basketball-sized gourds in each hammock, pea-pod-style, and wrapping the nets tightly so that the gourds couldn't move. I then tied the two pods together at each end so that my raft was shaped like a little boat. It didn't have a bottom, but the sides were close enough together so that I was able to sit atop the boat.

I was filled with anticipation as we headed once more for the river at 7:00 a.m. This time the raft worked beautifully, and I couldn't stop grinning. "*Carpe diem,*" I whispered to myself as I swirled through the chuckling rapids.

Janice later pointed out that, while *I* might think the boat was wonderful, it wasn't very showy. She suggested attaching a gourd head and tail and calling it "Gourdzilla the Sea Serpent," which I did to great effect. After making myself a gourd helmet, I was ready.

The parade turned out to be fun but a little anticlimactic. My raft went largely unnoticed in the jumble of decorated inner tubes, the occupants of which were busy negotiating the rapids. But Gourdzilla and I did go the distance—and there would be other gourd boats to come.

Wake-Up Calls
Small Town Girl Leaps into Fame

In the spring of 1967, Valdosta, Georgia was a medium-sized town trying hard to be sophisticated and cosmopolitan. The town had just built a fancy new city auditorium, complete with real spotlights and an orchestra pit, where school and community events could be held.

The annual Miss Valdosta High School pageant was a big deal in our town, and my class was to be the first to hold it in the new auditorium. Pretty or not, almost every girl who could afford a semi-formal dress with dyed-to-match shoes planned to be in the pageant; we all knew (the adults told us) that participating in such a production was Good Experience for a Young Girl.

The big night arrived. Never had any teen-aged small-town girls had more fun piling on eye shadow and mascara and hairspray than we did that night. Painted girls in pastel *peau de soie,* satin, and taffeta floated and fluttered around backstage, feeling oh-so-grown-up and gushing excitedly over each other as only south Georgia

girls can do.

After whispered last-minute instructions from our faculty director, the pageant finally began. And everything went just beautifully—until poor Vicky Clayton walked off the front of the stage.

One instant she was walking through her paces in a white antebellum-style gown, smiling and squinting into the bright spotlights; the next moment she was floating, feet-first, down into the orchestra pit before the audience's startled eyes.

Well, she didn't exactly float, but we all decided afterward that her huge skirt had had a parachute-like effect and slowed down her fall considerably, saving her from injury. After a half-second of stunned silence, the young master of ceremonies stammered, "I-I-Is there a doctor in the house?"

The town veterinarian came running down the aisle and eventually found his way into the orchestra pit. Word came quickly that Vicky wasn't injured, and the pageant continued. But each time a spotlight-blinded contestant came within five feet of the front of the stage, the audience—and the girls watching from the wings—gasped loudly and fearfully in unison. I don't know which danger was greater—another girl landing in the pit, or someone in the audience having a heart attack.

Finally, folding chairs were placed along the front edge of the stage. The pageant wasn't glamorous, but by then no one cared. We got through it.

The winner herself may be the only one who knows that she became Miss Valdosta High School on that night. But we all remember Vicky and the way she reminded us, albeit inadvertently, who we really were—just a bunch of small town girls still playing dress-up and not yet ready to fly.

Window on Another World

I worked in a Levi factory in my hometown of Valdosta, Georgia for one summer after high school graduation. The plant didn't normally hire seasonal workers, but our next-door neighbor, the plant manager, was nice enough to give me a job.

My first day was a classic introduction to the cold, cruel world. As I entered the windowless redbrick building, the bright lights, sharp chemical dye smells, and a cacophony of buzzing and clanging sounds coming from various machines, all bombarded my senses.

Even more disturbing were the hurried mechanical motions of the workers, whose pay was partly determined by their productivity. Even now I feel anxious remembering how frantically they worked.

I failed miserably at the first job assigned to me —a task involving scissors and speed—and angered the workers who had to slow down because of me. They didn't care how high my SAT score had been or whether I had been a leader in my school; they cared that I couldn't keep up the pace. I fought back tears and gained perspective on myself and the world.

On my second day I was moved to the belt loop department, where I didn't exactly shine but was able to function. My job was to stand behind a machine which, as a skilled worker fed strips of denim into it, spit out

loops at the rate of about two per second. I was supposed to discard the bad loops and place the good ones into numbered slots in a tray so they could be attached to jeans in the next department. It mattered that all the parts of the jeans be kept in numbered order because of variations in shades within the same bolt of denim.

Anyone who remembers the episode of *I Love Lucy* in which Lucy and Ethel worked in a candy factory, can imagine the belt loops popping onto a little conveyor as I tried to keep up with the machine. I worried constantly about the people who would unknowingly purchase Levis with faulty or mismatched belt loops.

Eventually I did become a fairly competent— well, passable—inspector. The other loop ladies decided I was an okay kid, even if I was the boss's neighbor, and took me under their wings. Genell, the woman whose loops I inspected, was especially kind to me.

Our supervisor, Maude, tried to make our little area homey, if you can imagine homey in a factory. There was a plywood wall that divided the loop department from the rest of the plant, and on that wall Maude had painted a window. It was complete with curtains, a shade pulled partway down, and a view of blue sky in the distance.

"If you get hot, hon, raise the shade," Maude laughed when she saw me gazing at her window. The

window was good for laughs, but it represented a human need to see beyond factory walls.

It seems to me now that I saw more through that bogus window than I could take in. It was a window on harsh working-world realities; on my own sheltered childhood that had to be left behind; and on a future that held fears and wonders yet to be imagined.

Real Magic

I should be embarrassed to tell this, but I was about 35 before I understood—or admitted—that magic is not *really* magic. Of course I knew that some tricks could be explained, such as the cup and ball trick most every child has enjoyed; but somewhere deep inside me, unexamined by choice, lay the belief that not all magic tricks had a rational explanation. I wanted to believe.

Then my partner, Janice, and I visited a magic store to shop for a gift for our nephew, who was about ten at the time and very much interested in magic. I told the clerk about Jamie and asked for suggestions. He showed us several impressive tricks; but each time he demonstrated one, he explained how the illusion was created.

Finally I asked him, albeit a little sheepishly, "But don't you have any *real* magic tricks?" Janice was shocked and probably embarrassed at my question, but the man didn't seem to understand what I meant. He showed me increasingly sophisticated tricks, each requiring more finesse and dexterity than the one before to create the desired illusion.

Finally, we made a purchase, thanked the patient clerk, and went on our way, leaving some illusions behind in the magic store. I felt as though I'd seen the little man behind the curtain in *The Wizard of Oz*.

I don't want to make more of this than it was. It

was just one of those little scrapes with reality that we all experience from time to time; however, I didn't have much use for magic afterwards.

My reason for thinking about that episode now is that, when we visited the Day Butterfly Center at Calloway Gardens recently, my belief in magic returned. I was reminded of one of the most spectacular magic acts in the book—the metamorphosis in which a caterpillar becomes a butterfly. I've stopped thinking of this phenomenon as just another miracle—a word that perhaps has lost meaning for me—and started thinking of it as real magic.

There's no trick, no illusion created when a butterfly emerges from a cocoon; this transformation, unlike the so-called materialization of a rabbit from inside a hat, is genuine. Yes, science can explain metamorphosis and other miracles such as the sprouting of a seed—but only to a point. The rest has to be chalked up to magic—*real* magic.

The Times They Were a'Changin'

I have a clear memory of a 1967 issue of *Life* magazine featuring color photos of flower children taken in the Haight-Ashbury district of San Francisco. There was one full-page picture in particular that drew me like a magnet, a shot of several young people wearing strange but pretty clothes, dreamy smiles, and flowers in their hair. I looked at the image many times over a period of weeks.

That summer I had an invitation to travel across the United States with my brother, who was to be stationed at Mather Air Force Base near Sacramento, California and didn't want to drive his new dark green Ford Mustang all that way alone. Bill was six years my senior and was a special mentor to me.

This was a wonderful opportunity for a high school senior-to-be; after much deliberation, my parents decided to let me go. Bill planned the trip so that we would have time for a little sight-seeing, including a day in San Francisco. There he would put me on a plane back home.

As we made our way toward the West Coast, we heard a song called "San Francisco" on the radio several times a day. The lyrics, written by John Phillips and sung by Scott McKenzie, went like this: "If you're going to San Francisco / Be sure to wear some flowers in your hair. / In the streets of San Francisco, / You're gonna

meet some gentle people there..."

Over and over—as we endured west Texas or marveled at the Painted Desert; as we exclaimed over Hoover Dam and then gawked at the lights of Las Vegas; as we sat in a traffic jam after visiting Disneyland and then headed up the coast toward the Big Sur Highway—we heard McKenzie's hypnotic voice inviting us to a love-in in San Francisco.

I must have secretly wished to experience the life portrayed in the magazine photos and the song. Maybe those people were having deep conversations about the meaning of life, the likes of which we didn't have in Valdosta, Georgia, even at Methodist Youth Fellowship meetings. Maybe those people had found the secret to a beautiful, magical kind of life unknown to me.

But what could a sixteen-year-old WASP in Ladybug shorts and John Romaine sandals have known or imagined about the hippie movement? I surely was only vaguely aware that hallucinogenic drugs existed as part of the new subculture. And I was way too naive to wonder about the sexual promiscuity that was widely associated with the flower children. If I'd been wise to those elements, maybe I wouldn't have been so drawn to the nirvana described in the song.

We made it to San Francisco. We saw Fisherman's Wharf and the Golden Gate Bridge and Candlestick Park. Predictably, we did not see a single flower child, much less discuss the meaning of life with

46

one. In the end I didn't even suggest to Bill that we look for the Haight-Ashbury district. It was one of those "slip-sliding away" moments, as lyricist Paul Simon would describe it.

I boarded a plane as planned and headed back to my predictable life of school and friends. I wasn't very happy with who I was—just a boring girl in Ladybug shorts, seemingly powerless to change my life; but I had no intention of being that girl forever.

Wildflowers
Celebrating Nature's Diversity

If someone had told me they'd seen a birdfoot violet blooming on this September day, I would have assumed they were mistaken. I'd have explained that such an occurrence isn't possible and probably would have made an educated guess about what wildflower the person had actually seen.

Birdfoot violets aren't like some flowers, such as whorled-leaf coreopsis, that have a license from nature to bloom off and on all summer; no, they have an appointed time and mission. These large purple roadside violets have always announced April and May to the people of northeast Georgia. Their role has been to confirm earlier signs of spring, to assure gardeners that the danger of frost is truly past and it is time to plant.

This showiest of wild violets has no business blooming in September. And yet I saw it myself. One little renegade is breaking all the rules and showing her true colors over on Satterfield Road even as I write. It's hard to know whether to be delighted or troubled by such a phenomenon.

We all like to know that there are a few things we can count on in this world, such as deciduous trees losing their leaves each autumn and wildflowers blooming at their appointed times. Yet it seems to me that much of the beauty of nature's laws comes from the possibility they provide for deviation. Artists agree that the essence of art is unpredictability, *i.e.,* the occurrence of variations within the context of a structure. Our planet, with its complexly related elements and constant modifications, is the embodiment of living art.

We forget sometimes that our own species is part of this enormous and complex work of art. We're capable of celebrating the diversity in nature—which we often perceive as being outside ourselves—but expect the members of our own species to fall in line, to grow and bloom in a set pattern.

There are among us beautiful birdfoot violets blooming out of turn, breaking the rules in harmless and fascinating ways. In them we have nothing to fear and everything to celebrate.

Others Pale to Summer's Best Hue

Summer whites are here in full force now. The roadsides are lavishly decorated with Queen Anne's lace and her raggedy companion, daisy fleabane—and a dozen other wildflowers in white.

A cousin of Queen Anne called Angelica is popping up here and there and is mistaken by some for her better-known relative. But those who observe her closely know that Angelica's white is not so white as the queen's and that her stalk is stiffer, not nearly so lithe and graceful.

There are other frilly whites blooming, too—dear pipsissewa, delicate flowering spurge, and equally delicate houstonia. The last of this year's crop of yarrow and ox-eye daisy can still be seen here and there along with pokeweed blooms, which are clearly upstaged by the eye-popping purple stalk of that plant.

And that's not all. Wild sweet potato vines and jimson weed, too, make dramatic statements in white for those who happen to be in the right place at the right time.

Other kinds of whites, too, go with summer: vanilla ice cream, cool white sheets, and cumulus clouds; new tennis shoes, sandy beaches, and laundry hanging out; freshly painted porches, curtains with eyelet lace, and whitewater rapids.

What is it about white and summertime? White is

a cool color that makes us think of happy times in the past when we didn't seem to feel the heat; when dirtying up a pair of new white shorts was the worst thing that could happen and a visit from the popsicle man with his gleaming white cart was the best.

Still, we can and should enjoy the summer we have in our grasp *now*. All too soon, the Queen Anne's lace will be replaced by purple asters—and this summer, too, will be a memory.

Green Woodland Orchid

We have a miniature swamp on our property, an elliptical-shaped bog about 25 yards long and half as wide. Ten years or so ago I spotted a single green woodland orchid blooming along the edge of this bog. It was a small plant with a couple of leaves at the base of a slender eight-inch stalk culminating in a cluster of pale green orchids, each about one-fourth inch long. On the day I saw it, I had been needful of a reminder that life holds surprises and wonders—which may explain why the diminutive orchid was so deeply etched in my memory.

I hadn't recognized the plant at first sight but found it in my favorite wildflower book, its photo easily recognizable. I was a little disappointed that my wondrous find was described as "*common* in or at edge of water, usually in woods." Still, the spark that had accompanied my moment of discovery remained with me and nurtured my spirit as only a new wildflower sighting can do.

As the years went by, I casually looked for the orchid just about every August but never saw it again. I wasn't really surprised about this; in many years of paying attention to native plants, I've seen species come and go from various habitats.

Recently, though, I decided to make an exhaustive search. Entertaining a hunch that I'd find

another green orchid at last, I planned to check the whole perimeter of the bog—which is intimidating even though small because of bugs and snakes and the chance of falling into real or imagined quicksand.

Very slowly and carefully, I worked my way around the area—as green and lush as any rain forest—looking for the proverbial needle in a haystack. The huge ferns alone could have easily concealed a miniature orchid from my view.

By the time I made it halfway around the bog, I still hadn't laid eyes on any orchids but was definitely seeing mental pictures of myself falling or being snakebitten. In order to conduct a thorough investigation, I had to step as close to the water as possible—so I wondered about quicksand: Is there any in our part of the world? If a person became mired in mud and died a slow death while being tortured by mosquitoes, would it matter whether the mud was actual quicksand or not? These kinds of neurotic thoughts always inspire me to be careful on solitary walks in the woods.

Nearing the end of my search, I tried to believe that I would still find the orchid. The truth is, I needed inspiration of the kind the sighting had given me ten years ago— reassurance that life holds surprises and wonders.

I reached the spot where the bog empties into a tiny stream, and still no orchid. It was the eleventh hour, the bottom of the ninth inning. As I carefully scanned

the area that held my last hope, there it was: a lone, fragile green woodland orchid, whose blooms were well past their peak of beauty, but no matter; I knew what I was seeing. Sighing with satisfaction, I took a picture and headed home to nurse my bites.

Had the plant itself not been evidence enough of life's wonders—and it was—the miracle of *finding* it would have been enough.

Portraits

An Unsung Philosopher

My father—his name was Bill Wilson—was a fun guy and an unsung philosopher. Unsung by the world at large, that is; but those who really knew him appreciated his unique perspective on being human. At the heart of it was the simple instruction he often gave to his children when we were growing up, especially when we were teenagers: "Don't take yourselves too seriously."

The message is actually a very serious one. To understand it means not only to value the humor in life, but also to see oneself in perspective—as someone who tries hard, suffers, cares, and loves, absolutely—but who all the while sees and smiles at one's own human frailties and resists the siren song of self-importance.

Daddy could make light of almost anything and used wordplay to impart to us his sense of fun. He regularly quoted all kinds of fun poems, including Gelett Burgess' "The Purple Cow"; Lewis Carroll's "The Walrus and the Carpenter"; and various limericks by Edward Lear. He loved Robert Loveman's "April Rain,"

the first two lines of which are "It isn't raining rain for me / It's raining daffodils!"

Daddy loved to read the comic strips, and his laughter reverberated through the house after church every Sunday. When February 22 came around, he usually announced George Birthington's Washday. He often asked children questions such as, "If the plural of mouse is *mice*, don't you think the plural of house should be *hice*?" And, as our frazzled family finally pulled out of the driveway on trips, he *never* failed to exclaim, "We're off, like a herd of turtles!"

Other "Daddyisms," as our family called them, included "the worst beer I ever tasted was delicious"; "wherever you go, there you are"; "don't sweat the small stuff"; and "we all need hyacinths for the soul." The last refers to a poem he loved by a thirteenth century Persian poet named Mosleh Eddin Saadi.

Not surprisingly, Daddy had quite a repertoire of funny stories. A special favorite was the one about the orange-glazed donuts. When our family lived in Valdosta, Georgia in the '50s and '60s, he often traveled to Jacksonville, Florida in his work for the FAA. He enjoyed taking a shortcut on a back road that led through swampy pine woods and tiny towns such as Needmore, Edith, and Moniac. On the outskirts of one of the towns was a beat-up little roadside restaurant, the kind with a little take-out window in the front. Daddy discovered that the owners made delicious orange-

58

glazed donuts, and he always looked forward to this treat on his trips.

One day he was dismayed to see that the donuts were no longer in their usual place. When he asked about them, the proprietor drawled, "Well, we quit making those; we just couldn't keep 'em."

Daddy loved that story. It appealed to his sense of the absurd and had messages for him. I believe he found the donut lady inspiring because she didn't take her donuts or herself too seriously. Unlike the stereotypical American entrepreneur, she wasn't going to get carried away making donuts for every Tom, Dick, and Harry just because the demand was there. Apparently money wasn't a big motivator for her, and she wasn't going to let her life become a struggle to keep up.

I think, too, that Daddy loved the story because it was an illustration of the unpredictability of people and life, a reminder that life holds delightful surprises and regular opportunities to learn and laugh if one is receptive to them.

As I reflect on Daddy's philosophy now, five years after his death, I know why his insistence on humor was so important: Children need to be taught and shown when they are young that *life should be fun,* so that they can carry this knowledge forward into their lives and so that, whatever awaits them, they can try to view it philosophically and with humor. I hear my father's laughter every day, and I am thankful.

The Fabric of our Lives

I was about 40 when I wrote this piece. My mother was fast becoming paralyzed by ALS, and I wrote it for her as well as for myself.

I've been having trouble lately seeing to thread my sewing machine needle; it's strange to realize that my mother was about the age I am now when she first started to need my eyes for this little chore. Performing the delicate task for her made me feel important.

Now Mama's machine is one of my prized possessions. She bought it in 1950, the year I was born, and she sewed enough clothes over the years to stock a small children's clothing store. The black Singer with faded gold detailing has millions of miles on it.

From the time my sister, Nancy, and I were big enough to follow her around the fabric store, Mama took us to pick out patterns and material. She gave us enough guidance to teach us her version of good taste; but she listened carefully to our opinions and made us feel that our ideas were valuable.

Those hours spent together in fabric stores gave me an experience of possibility that still affects my every artistic effort. I can close my eyes and smell again the sharp yet pleasant odor of new fabric; see the expression on Mama's face as she focused on a new pattern and calculated the number of yards she needed to buy; and hear the sound of the clerk's sharp scissors as she cut the material.

I can see some of the fabrics: a bright print of apples, oranges, and pears we chose for a spring dress; a rich burgundy and navy plaid we picked out for a fall one; some pale pink wool we found for a skirt to match a store-bought sweater.

After the planning and buying sessions, Mama couldn't wait to get started cutting and sewing. She worked with amazing energy. Night after night, while the rest of the family did homework or read or watched TV, we heard the sewing machine in the back of the house, clicking as hard as it could go.

She made it whir with creativity, efficiency, and purpose. On the rare occasions when I sew on it now, I love remembering how the sound of it made me feel as a child, how the little machine seemed to sing about motivation and satisfaction and the importance of making things for the people we love. Words could never have explained those values to me the way Mama's actions did as she spoke through "the machine," as she called it.

My mother is not able to sew now, but she accomplished more in the first 65 years of her life than many people could in several lifetimes. I hope she feels as good as she deserves to feel about the fact that, while she was able, she didn't waste her God-given energy and talents.

And I hope she feels good about the spiritual as well as material fruits of her labors. I know I do.

Swamp Fever

Messages Beneath the Black Water

*I grew up near South Georgia swamps but didn't become fascinated
by them until my thirties. The experience described here, written in
the late 1980s, was literally an earth-shaking one for me.*

Janice and I visited the Okefenokee Swamp
recently. The first thing we learned about it was the
origin and meaning of its name. The Seminoles coined
the name, meaning "land of the trembling earth," long
before they were chased into Florida by newcomers to
Georgia, *i.e.*, white people.

I'd heard the translation before and thought it
poetic; but I didn't know enough to understand that the
name has its basis in fact, not myth or poetic imagery.
Maybe most people know more about swamps than I do,
but in case some readers do not, I'm offering a short
course in trembling earth.

In what was once a series of huge lakes in
southeast Georgia, earth is constantly being formed
when peat moss, formed by decaying matter on the
bottom, is propelled to the surface by methane gases.
Gradually, enough peat moss accumulates in an area to
form a floating island.

Plant life starts to grow on the island, and, eventually an area of land exists which looks like solid ground; but there is still water under the island. Walking on land a foot or two thick is, as our guide described and demonstrated, like walking on a waterbed. Thus the name "trembling earth," meant to be taken quite literally.

All the swamp tourists in our group were intrigued by this information. I believe our fascination stemmed partly from the realization that much of the land we saw from our boat was not the solid ground it appeared to be; we were witnessing one of nature's illusions on a grand scale. Perhaps we liked being reminded, too, that there are unfathomable mysteries lurking beneath the surface of the earth, just as black water underlies the floating islands in the Okefenokee.

For me there was also an awareness that, while trembling earth as a physical reality is limited to certain geographical areas, the phenomenon is an apt metaphor for a planet in crisis. Maybe if we could literally experience trembling as we walk on our planet, we'd be aware in a new way of its fragility.

We are on shaky ground.

Sanctuary in the Swamp

It was already hot in Southwest Florida at 10:00 a.m. when Janice and I saw the Corkscrew Swamp Sanctuary sign and pulled off I-75 to investigate. We followed the signs to a narrow, deserted road that looked anything but promising. Heat waves rose from the pavement, which cut through mile after mile of scrubby vegetation. The scene put me in mind of T.S. Eliot's poem "The Waste Land."

I watched the trip odometer a little anxiously as mile after mile registered without our seeing any more signs about Corkscrew. Five miles of desolation became ten and then twelve—but we pressed on, having invested too much curiosity to turn back. At last, signs directed us to turn down another deserted road and then another. I thought we must be the only people crazy enough to visit such a God-forsaken "sanctuary."

To my surprise, the parking lot boasted about 40 cars; other humans had been drawn from the waste land to the idea of an oasis. We quickly realized that we were indeed entering a sanctuary in every sense of the word. Many visitors entering the park carried the trappings of a religion of sorts; but instead of rosary beads, skullcaps, or Bibles, there were binoculars, sun visors, and field notebooks in evidence. The people working in the small headquarters building were subdued and earnest, like greeters in the vestibule of a house of

worship, as they handed out pamphlets to guide us.

A boardwalk led us into an ancient cypress swamp. As we approached it, people chatted and pointed out birds and wildflowers. But as soon as we entered the cool, watery forest, a sign requested silence of us. We spoke in whispers as people do in libraries or churches. From time to time we dutifully consulted our pamphlets, which, like books of worship, explained to us at numbered stopping points the wonders of strangler figs, leather ferns, pig frogs, and pickerel weed. I moved along in a daze, drinking in the life-sustaining scenery.

At one point the boardwalk led to an observation deck that afforded us a chance to sit and watch and meditate. People came and went quietly, respectfully. "This is a place where a person should be alone," whispered one woman. Near the end of the two-mile loop, a couple of naturalists were available to counsel with worshipers in hushed voices, answering questions about the life cycles of cypress trees, bromeliads, and lake lettuce.

Janice and I left Corkscrew reluctantly but with new inspiration; our departure felt remarkably like leaving church after a meaningful service. I thought often about the experience during the remaining days of our trip. As soon as we returned home, I looked up the word *sanctuary*. The first definition was perfect in its simplicity: "a holy place."

Then the logical conclusion and the reason I had

been drawn to the whole sanctuary analogy became clear: If Corkscrew Swamp—or the Chattahoochee National Forest—is a sanctuary, then the whole planet must be a sanctuary as well. We're on holy ground. We should walk softly and speak in whispers.

Just Silly

Hoe-lympics, Anyone?

I was literally hoeing a seven-acre field of gourds when I had the hoe-lympics idea . I still like the concept.

The 1988 Summer Olympics are underway, and I have a question: Why isn't there glory and recognition for people who excel at doing ordinary, useful things?

Most people have no idea, for example, that handling a hoe can involve as much skill as handling a vaulting pole or a polo mallet. I know several people who deserve to make the Olympic trials in hoeing; their grace and finesse would be a joy to behold as they eliminated all the morning glories in a fifty-foot bean row in record time. A hoer's reward comes from the garden itself, you may say; I say champion choppers deserve to be celebrated by fellow human beings who value their skills.

And what about cutting corn, snapping beans, or peeling apples? I've seen skilled hands fly almost faster than the eye could see as they turn unmanageable produce into real, consumable, nourishing food. How could any skills be more noble? Certainly stamina,

69

determination, and a strong sense of purpose are required. Aren't these among the qualities we so admire in Olympic athletes?

And why not include wood-splitting as a respected sport? Think of the hand-eye coordination involved, not to mention strength and timing. Northeast Georgia would be well represented on the USA's wood-splitting team. At last we'd get to see one of our own competing on television.

Another potential Olympic sport is needlework. Knitting, hand quilting, and other forms of needlework require many years of dedicated training and practice for one who wants to attain Olympic-level skill. We all know people who could compete for medals in these games.

Okay, now that I've used the word *games,* I have to own up to the reason these skills will never be a part of the Olympics. A game is, by definition, an activity that isn't useful, at least in the sense that it does nor yield a product. Only non-productive skills rate Olympic recognition.

I'm not questioning the very real value of games for recreation and character-building. But it *is* interesting that the productive skills at which country people excel don't get much official notice in our society. It's true that these skills are recognized at county fairs and such; but a blue ribbon pales in comparison to a gold medal.

Having said my piece, I intend to enjoy the Olympics and to draw inspiration from them like everyone else. But I'd dearly love to see a medal being hung around the red neck of a champion hoer as our national anthem is played.

Porcupine Hunt

I'd never given much thought to porcupines until Janice and I visited northern Michigan and found out that the strange, spiny creatures are common in the upper Midwest.

We were at the Sleeping Bear Dunes National Lakeshore when I had a chance to question a park ranger: "Do you see porcupines here very often?" I asked, a little excitedly.

He looked at me strangely and kind of shrugged. "Sure, I guess so." Apparently, my question had been the equivalent of someone asking a southerner about squirrel sightings.

I had hoped he would expound on the subject of porcupines, but most Michiganders don't seem to enjoy expounding like we Georgians do. I had to dig for information.

"Do people ever get hurt by them?"

He looked at me even more strangely. "Not unless they're crazy enough to brush up against one."

I was genuinely surprised and disappointed, having been under the illusion that porcupines could fling their quills with considerable force when threatened. I foolishly admitted as much to the ranger, who shook his head and moved on.

I had embarrassed Janice. As we walked away, she tried to coach me on my pronunciation. "You sound

like a little kid, the way you say "por-key-pine." You're supposed to say "por-cue-pine."

In succeeding days, we headed further north to Mackinac Island and then to the Upper Peninsula. I kept my eyes peeled for porcupines. Even after the wake-up call about quill-flinging, I still hoped to see a live one crossing the road.

I asked people here and there about porcupine sightings, pronouncing the word correctly and trying to act nonchalant. We learned that the quilled critters are unpopular because of their habit of eating signposts and bridge underpinnings. People weren't particularly eager to talk about porcupines.

So I had all but given up the search when we saw the real thing on Highway 123 between Paradise and Newberry. Well, like I said, it was ON the highway— road kill. Still, we turned around and pulled off the road to get a closer look at the unfortunate animal.

It appeared to have been dead for only a short time and was not gory in the least. Janice waited patiently and let me look at it for as long as I wanted. I even took a few souvenir quills, but I'd rather have watched—from a safe distance—that porcupine alive and bravely flinging those quills. Instead, I returned from Michigan minus one more childhood illusion.

All Frogs' Day

The idea of celebrating All Frogs' Day came as an indirect result of an after-Christmas conversation last year—you know the kind—about how great it would be to create a stress-free holiday, one that folks could enjoy without pressures and predetermined expectations.

The discussion was promptly forgotten—until the frogs began singing the following March, that is. As my friends Janice and Mildred and I sat outside one evening enjoying the music of the peepers around the pond near our house, it was suddenly clear to us that we should indeed create that stress-free holiday. We'd call it "All Frogs' Day!"

The day we had the idea happened to be the third Saturday in March, so we decided that we would in future years celebrate the holiday on that day. We could hardly wait for the following spring.

So this year, All Frogs' Day was one of the first days to be marked on our new calendars. We talked in vague but glowing terms about a celebration to be held on March 21 and began to indoctrinate more friends, who instantly liked the idea.

"All Frogs' Day"—it had such a nice ring to it. What a wonderful rite of spring, a perfect occasion for partying, gift-giving, and mysterious frog rituals. The potential for songs and holiday paraphernalia seemed endless; Hallmark would have a field day, we laughed.

The only trouble was that the new holiday was intended to be stress-free. To plan a big party, complete with all the appropriate frog trappings, would have been way too taxing. As the big day drew closer, we continued to talk about the holiday but were unable to commit to any specific plans. I began to feel anxious about our failure to plan a celebration.

Finally, less than a week before the appointed Saturday, we had to come to terms with the fact that there would be no party for All Frogs' Day. This holiday, we realized, must be celebrated in non-stressful ways; to do otherwise would defeat the whole purpose.

So I plan to celebrate this Saturday, but only in ways that will be fun and easy. I hope you'll do the same. Go someplace where you can hear the peepers. Practice those frog sounds you haven't made since high school. Greet your friends that day with the words "May you feel as joyful and relaxed as a tree frog in early spring."

I am counting on you to help establish All Frogs' Day. Don't let it be the holiday that died in its infancy for lack of stress. But, whatever you do, don't let Hallmark get wind of it.

Tips for Professional Litterers

Janice and I have been picking up litter as part of the Georgia Adopt-a-Highway program. It's quite satisfying to participate in a large group effort and to be able to see the results of one's labors.

I was thinking, though, as I bagged large quantities of other people's garbage last week, that perhaps some suggestions to litterers might be in order. If they would only do their part, the clean-up effort could be more efficient.

So if any litterers are reading this, I ask you to consider the following requests:

1) Please try to toss your litter about two feet from the edge of the pavement so that we can walk along comfortably and safely on the shoulder as we pick up after you.

2) Try to throw glass bottles on soft, grassy areas so they don't break. Surely you can understand our resentment at having to pick up hundreds of small pieces of glass. Besides, broken glass cannot be recycled!

3) Please don't relieve yourselves or spit tobacco into cans and bottles. That's adding insult to injury.

4) And please empty unused liquids from bottles and screw tops back on so they won't get filled with rain water. Any bottle containing liquid

strikes dread in the hearts of the clean-up crew. (See #3.)

5) If you are disposing of fast food wrappers, please put small items such as ketchup and salt packets inside the bag and twist the bag securely. This way maybe your roadside janitors will have to bend down only once per fast food meal instead of five times.

6) Do not try to see how far into the woods you can throw your whiskey bottles. Those of us who have limited time for picking up may be forced to leave them there and then feel guilty.

7) Before you throw out such things as lawn chairs, flower pots, and shoes, keep in mind that you can sell these items at a yard sale instead and make a little cash for buying more fast food, beer, and cigarettes.

8) Try to recognize the kinds of plastic which, after a few months outside, will fall into thousands of pieces when someone tries to pick them up. Please enclose these items in a container of some kind.

9) Kleenex and toilet tissue are other no-nos. It is simply too much to expect someone to pick those up for you.

10) Try to support recycling efforts by tossing cans, bottles, low-number plastics, and batteries near the home of someone you know to be a

compulsive recycler. Litterers, like everyone else, must come to terms with the need to recycle.

11) Come to think of it, you know what would be even easier than following all of these instructions? Maybe you could just keep a litter bag in your car. Oh, and don't worry about disappointing the pick-up people when our jobs become obsolete. We'll get over it.

For the Birds

Flight

This piece was written for the current collection, but its message and ending are taken from a much earlier column.

In a beautiful poem called "The Windhover," Gerard Manley Hopkins describes the flight of a falcon and the poet's experience of watching that spectacle.

Anyone who has ever watched a hawk in flight can identify with Hopkins as he describes his feelings: *My heart in hiding / Stirred for a bird,—the achieve of, the mastery of the thing!*

The flight of birds in general and hawks in particular has always fascinated and inspired humans. Because they fly high and often cruise as they hunt for prey, hawks are known for their ability to "wow" spectators.

The sight of hawks on the wing in North Georgia is fairly common, but not nearly as common as the sight of their ancient cousins, the turkey buzzards. Many people can easily mistake a lone buzzard for a hawk at a distance. A hawk flaps its wings more often than a buzzard, and its wings look smooth on the ends; on the

other hand, the end feathers of a buzzard's wing can be seen individually, like fingers.

I've had these differences explained to me and been present when they were described to someone else who has commented on the flight of a buzzard, mistaking it for a hawk. One moment, a person is exclaiming over the beauty of a bird in flight; the next moment, after learning the identity of the bird, the disappointed spectator no longer perceives the sight as beautiful.

Yet the flight of a buzzard actually *is* very beautiful. Hopkins' words could as easily describe a vulture as a falcon: *... striding / High there, how he rung upon the rein of a wimpling wing / In his ecstasy!*

Why should a hawk be more honored than a buzzard, a trillium more treasured than a dandelion? We often see beauty, even in nature, through eyes which value exclusivity. If we could learn to see natural phenomena through neutral lenses, we'd all live in a perpetual state of wonder.

Prophets of Spring

I was obviously preaching myself a sermon here; but it still speaks to me 25 years later.

Who can say why the robins chose the coldest day of the year to stop over in North Georgia?

For years I've noticed their sudden and impressive appearances in early February and have remarked to myself that robins are really the *prophets* of spring rather than the ushers of the season they're reputed to be. But never have I seen them about on such a day as today.

It's the kind of day when humans talk of the weather with a hint of ancient fear in their voices; when those on errands are blown, red-faced and shivering, from cars to buildings; when the wind seems like the bitterest enemy of all living things.

Yet there were flocks of robins in our yard all day, carrying on in spite of the icy winds howling around them. They hopped on the ground outside my kitchen window, cheerfully pecking for worms that I knew couldn't possibly be there.

I went for my binoculars at one point, worrying that these marvelously red-breasted, endearingly spunky birds had made a severe miscalculation this time and that they might go hungry. Focusing on first one robin and then another through the binoculars, I discovered that they were indeed finding worms, and some very

juicy-looking ones at that.

I watched one particularly determined bird and saw her attack the ground repeatedly with her yellow beak until she hit pay-dirt. What did it matter to her if she came up empty six times for every success? She wanted to live, didn't she? One does what one must.

Periodically the little flock seemed to play games of follow-the-leader or tag, flying defiantly into the wind and being blown off course time after time. They didn't stop to agonize over the risks of flying into the wind but simply kept going.

I didn't see a single bird huddling alone in despair against the trunk of a tree as I would have been doing. And I didn't hear any complaining. The robins were going about their lives, which included some work, some play, and some rest. It was every bird for itself— and yet there was definitely a kind of camaraderie among them.

All in all, the robins seemed like well-adjusted creatures. Sure, you say, the lucky twerps don't have to think; their tiny brains are incapable of reasoning, and their instincts tell them just what to do.

We humans, on the other hand, are blessed with great intelligence as well as animal instincts. Ironically, our greatest challenge is learning when to turn off our superior brains and let our instincts teach us how to be happy.

Outclassed by Wildlife

I've been stalking wild ducks again. Many of them have visited our pond this fall—mostly ringnecks and wood ducks—and I'm like a child in my fascination with these elusive creatures.

The ringnecks have been the most faithful. Day after day, I find them here, gracing us with their quiet presence. Some days there are six or seven, some days just one or two.

They float on the pond all day, a black and white picture of serenity and composure. Not content to admire the ducks from a distance, I slip down toward the pond now and then, hoping for a closer look.

Unruffled by my approach but very much aloof, the ducks float effortlessly and quickly to the other side of the pond. To say they outclass me is an understatement; but I keep trying, a clumsy human drawn to their silent beauty.

The wood ducks are a different animal altogether but equally beautiful and mysterious. They huddle in one shallow area of the pond and are well-camouflaged until they take off at the least provocation. I watch them fly away in formation and vow not to frighten them again.

Sometimes I see them return, hit the water in a flash, and once again disappear against the grasses along the shadowy bank. It all happens way too fast for my

inferior human eyes; consequently, I never get to see the brilliant colors of the wood ducks except in my bird book.

At dusk I hear their soft, squeaky voices and see their faint outlines as they hunt acorns in the little grove of burr oaks near the pond. I want to come closer, but they have taught me that I must respect their wildness.

The wood ducks often have to share the oak grove with a young deer, but they get along fine together; they share their wildness, while I am only a would-be intruder. I wish I could know these wild creatures, but they have declared themselves off limits to me.

We humans think we own the planet. But as I watch the ducks in the near-darkness, it seems to me that we are the strangers here. We are not privy to all that goes on in this world. We are outsiders, and we are outclassed.

Keeping On
Potential Isn't Everything

I'm betting—with an acorn in my pocket—that no one reading these words has been on an autumn walk in the woods *without* picking up at least one of these beauties, preferably one still clinging to its charming cap.

Why do we do it? They're irresistibly cute, for starters. Mother Nature is a genius at packaging; in the case of the acorn, Madison Avenue can't compete with her for eye appeal, practicality, or recycle-ability.

But acorns have more than eye appeal; their memory appeal is equally powerful. Most of us remember reading about acorns in our primers, seeing drawings of them with quaint hats and cartoon faces, and perhaps coloring them with crayons—in some cases, before we had ever held the actual objects in our little hands and felt their delightful hard smoothness.

When it comes to things all-American, acorns are nature's equivalent of apple pie and hotdogs. They're clean, firm, and uncomplicated; they're collectible; and

they're inspiring in their perky, compact way. We've all heard that "mighty oaks from tiny acorns grow." There may not be a more widely understood symbol of potential in our culture.

Interestingly, my dictionary describes the acorn as a fruit rather than a seed. Reading that definition opened a mental door for me. Mr. Webster made me realize that, although I'm obviously charmed by acorns, something has been bothering me about them.

Here it is: Fall is not the time to be weighed down by too many thoughts of potential. It should be more of a time for enjoying harvests, for being content and postponing thoughts about potential until after a winter's rest. So why not start thinking of the acorn as a fruit?

I'm not denying that acorns can speak eloquently about potential. And I love that message—in the spring. But for now I simply want to admire their beauty for what it is in the moment. I want to be able to carry one around in my jeans pocket all day and reach in and hold it in my hand from time to time—without giving one thought to that loaded word *potential*.

We all know, anyway, that not every acorn turns out to be a giant oak, or any oak at all. But each one *is* a beautiful fruit in the fall. Potential isn't everything.

Take Time in Life

The little-known song that is the subject of this piece has been playing in my head periodically for many years; when it returned recently, I wrote about it for this collection. Readers can hear the tune by going to youtube.com.

My first full-time job after college graduation was that of a Field Service Coordinator for the Atlanta Council of Camp Fire Girls. This vague title meant that I organized new groups, recruited adult leaders, and provided support to the leaders of existing groups.

A typical group consisted of a dozen or so girls aged ten to twelve. Unlike the more familiar Girl Scouts, the Camp Fire Girls program was based on Native American lore. Members wore blue skirts, white blouses, and blue felt vests on which they had sewn colorful wooden beads earned by participating in various activities. Advocates of this program believed that it was more geared to girls than the Girl Scouts program, which was modeled after Boy Scouts with its green clothing and merit badges.

I didn't participate in either program as a child; but having worked at a Camp Fire Girls camp in Toccoa, Georgia during my college years, I was idealistic about the program and found it meaningful. Being a *professional* Camp Fire Girl, however, proved surprisingly stressful for me. Not only was it my first full-time job, but I didn't have the benefit of a job description or adequate training and guidance.

Moreover, it was difficult for a woman barely 22 to be offering "expertise" to the group leaders, who were grown women with families. They didn't take me very seriously, and who could blame them?

I worried constantly about doing a good job and relating well to the group leaders. To make up for my shortcomings, I worked extra hours—when I could figure out what to do. For someone so young and working in a job that should have been fun, I felt harried, confused, and stressed much of the time.

Once I was invited to the monthly meeting of a group of girls in Decatur whose leader I knew and admired. We met in a shady churchyard where we sat in a circle on the ground. There happened to be a new girl in this group who was originally from Liberia, Africa; the group's program on the day I visited was about Liberian culture.

As part of the program, the new girl along with the leader taught us a Liberian folk song called "Take Time in Life."

The words went like this:

As I was passing by my auntie called to me
And she said to me you'd better take time in life.
You'd better take time in life, oh ___
(here we inserted a name)
Take time in life.
Take time in life, oh ___
Take time in life.
Cause you've got a far way to go.

Each time we sang the chorus, we addressed it to someone in the circle. We sang the words to every person in the group, including me. There was something very moving about hearing the advice from those young girls, who by virtue of being children *knew* how to take time in life. They were blissfully ignorant about the adult world to which I was struggling to adjust. When it was my turn, I remember getting choked up as they sang to me and hoping no one knew.

Forty-something years have gone by, and the song still comes back to me. A lifetime later, I sit at the computer trying to communicate this memory and take its message to heart once again. The battery clock across the room is literally and figuratively marking time, ticking to the beat of the song those Camp Fire Girls are still singing to me through the years: "Take time, in life, oh Priscilla, take time in life."

After the Peak

My parents called me from Savannah after this column appeared in the White County News *in 1988. They were quite moved by it, partly because they were living with my mother's fatal illness. Their response to the piece meant a great deal to me.*

Our fall color, much touted in northeast Georgia, is past its peak now. The time for exclaiming over multi-colored mountains, for wondering how long the color would last—and for dreading the time when it would begin to fade—is over.

It was awe-inspiring, like always. But many of us can't enjoy fully the beauty at its height for fear of missing something. "Is this the peak?" we ask ourselves. "Now? Not quite." "Almost!" "Did I miss it? Did I blink my eyes at the wrong time?"

The hard thing to learn about fall color and life is that we can't make time stand still; so we sometimes have a feeling of desperation instead of pleasure as we try to enjoy the peaks in life.

The reason I so enjoy this time *after* the peak is that the pressure is off. The "peak" is unquestionably over, and instead we have what feels like infinite time to enjoy subtler beauties.

Now is the time for solitary walks in the woods, for crunching new-fallen leaves and once again wondering if the Cherokees were truly able to walk soundlessly, even in the fall.

Now is the time for experiencing the season on a

personal, human-to-tree basis, for hugging a half-gold tree and standing quietly in its puddle of leaves while more come down around us.

There's time now to think about the mysteries of the seasons and to take a lesson from our leafy co-inhabitors of earth about how to give back. There's time to commune with the trees, to think about being more like them: more quiet, more purposeful, more sure of who we are even amidst constant change.

Now is the time for rides on little dirt roads where one can get lost in a kind of fairyland. Because many of the leaves have fallen, one can see deep into the woods where brilliantly colored jewels still dangle.

Finally, it is time for making a transition to the indoors—figuratively and literally—and for taking stock of ourselves in preparation for the holidays and the coming new year. It is a special time, even if the "peak" is over.

Are there really peaks in life? If so, they are not the most important part.

Sand Dollars

I don't mind stating publicly that I inherited quite a few dollars from my mother: 37 to be exact. That might not sound like much money to a banker; but in the currency of the sea—sand dollars—she left me a small fortune.

Actually, she had a total of 74—a large fortune indeed—packed with tissue paper in a modest cardboard box. My sister, Nancy, and I decided she would want us to divide them; and, as we dutifully counted the dollars, we were amazed at their number. We'd probably taken for granted that Mama had a small stash somewhere; but the magnitude of her wealth took us by surprise.

How many years had she been saving those hard-earned dollars? No doubt she had walked a mile on the beach for every gray-white coin that she'd found. The idea of *buying* shells in a store would have been completely foreign to my mother.

Such an inheritance is a large responsibility. Sixty-odd years of walks on the beach are not to be taken lightly. And in a way the sand dollars do represent some of life's greatest treasures: the feel of cool wet sand on bare feet; the thrill of seeing the sun rise over the Atlantic through sleepy eyes; the miracle of catching a whiting in the surf; the camaraderie of those who walk together on the beach; the glare of sunlight flash-dancing on saltwater.

Still—what does one *do* with 37 sand dollars? How does one invest such an inheritance for the maximum return? I didn't know. That's why I kept my fortune in a cardboard box for almost ten years.

Then I remembered that my mother had not intended to keep her dollars hidden away under the proverbial mattress; she had in fact spent dozens of them in various ways during her lifetime. She'd made all kinds of crafts for her church bazaar and for friends and relatives. And she'd no doubt had ideas and plans for her remaining dollars.

So finally I understood that the way to be a good steward of my inheritance was to give it away. In October of 2000, I took most of my dollars, still in their original box, to Isle of Palms, South Carolina. Early on a drizzly morning when no other soul was out, I walked along the beach and dropped the dollars one by one, 30 yards or so apart. The tide was going out, so I felt sure people would find them by late morning. The rain had stopped by the time I turned back toward the motel, and other beach-walkers were appearing. I was pretty sure—well, I wanted to believe—that I saw a child finding one of the dollars way down the beach.

I hope the new owners of my mother's riches were delighted by their discoveries and that in future days the shells will serve as reminders of the *real* treasures shared with loved ones on the beach.

A Brief Sequel to Gourd Girls

My life partner, Janice Lymburner, and I have been co-creating a business called The Gourd Place since 1976. In 2005 we published a memoir, Gourd Girls, *in which I chronicled not only the evolution of the business, but also our life stories, including our coming out as a lesbian couple in our rural community. The book is out of print but is available online as a used book or in Kindle format.*

The 2005 publication of *Gourd Girls* was a watershed event for Janice and me. As a result of my writing the book—with much input as well as hand-holding from Janice—we both gained a unique perspective on the life we had created. What a feeling it was to hold our published and seemingly complete story in our hands.

As writers of memoir will do, I endeavored to tie up our story honestly but neatly at the end. When the narrative ended, the two of us were enjoying a little financial relief as a result of the popularity of our Gourd Impressions pottery; we had finally accepted the moniker "gourd girls"; and we had for the most part become happily philosophical about the joys and challenges of the gourd life. I was thankful to be able to end the book on a positive note after putting readers through some hard times.

Yet people immediately began asking about the sequel; and as a result, I experienced a discomfort that I was unable to articulate at the time. My fear was that there might be no sequel, real or metaphorical—that

somehow the gifts of the Creative Force might not continue. Maybe by telling all and tying our story up so neatly, I had brought an end to the magic.

But it wasn't long before the Creative Force made its comforting self known again—and again. This Force is real and continues to be the reason I look forward. It is a never-ending source of new stories available to every person in every moment.

So now, in 2017, I find that there is indeed a sequel to be written. A book-length version is not in the cards; but the publication of this book of essays gives me the opportunity to write a brief sequel after all.

~

The existence of *Gourd Girls* immediately changed the way Janice and I related to visitors in the shop in that it outed us to them as a same-sex couple. Although we'd been out of the closet for many years before the book was published, we'd continued to feel uneasy about certain often-asked questions such as "Are you two sisters?" or "Does your husband cut the gourds?" or "Which one of you lives in the little house next door?" It wasn't that we were afraid to answer the questions honestly; but we didn't want to make visitors uncomfortable in our shop, where our first mission was hospitality.

After *Gourd Girls* became part of the landscape, anyone who looked through the book on display was likely to learn that Janice and I were a same-sex couple.

Therefore we began to take personal questions as invitations to speak freely, yet in a way that I like to think is disarmingly sweet but matter-of-fact.

Only one person returned the book, a lady who apparently had not perused it carefully before buying it. She walked into the shop, handed the book to Janice, and said, pointedly, "This is not something I want to read." Janice smiled her usual sweet smile and refunded the lady's money; the two of them said goodbye quite amicably.

On the other hand, many people returned to the shop or visited for the first time *because of* the book— an unanticipated result of sharing our story. Even now, almost twelve years later, a surprising number bring up the subject of *Gourd Girls*. They seem to feel a connection with us and want to tell their own stories after reading ours.

Sometimes the connections are clear: Family members of ALS victims want to talk. Or parents tell us about their gay or lesbian sons or daughters; some say, to our deep delight, that the book has helped them to understand their offspring. Or entrepreneurs and inventors tell about their ideas and plans, often asking for advice about applying for patents. Some artists want to talk about their own artistic journeys; and other appreciators of our story like to share books that are important to them.

The love and admiration that Janice and I feel for

our fellow humans have been strengthened, all because of a small, self-published book.

~

When *Gourd Girls* went to press in the summer of 2005, our pottery patent application was still bogged down in the U.S. Patent and Trade Office; but it turned out that the book itself played a part in the eventual awarding of the patent.

One day in the spring of 2006, Jean and Steve Kerr walked into our shop and began exclaiming over the pottery. Both were cute brunettes, Steve a teddy bear type and Jean a stylishly-dressed woman. The four of us hit it off and ended up talking for a long while. They bought quite a bit of pottery and a copy of *Gourd Girls* as well.

The idea of using gourds as molds for a slip-casting process had come to me out of the blue in 2000. This process captures not only the shape of the gourd mold, but the beautiful organic textures inside, imprints of veins that nourished the gourd during its formation. I had written at length in *Gourd Girls* about the adventure of making this unusual idea a reality and about our efforts still underway to get a patent.

Steve called the very next day after their visit. "I stayed up all night reading your story," he told Janice, "and I want to help you get your patent. I may not have mentioned that I'm a patent attorney with an Atlanta firm." Thanks to this wonderful friend's *pro bono* help,

we had our patent by the end of 2006, a year after *Gourd Girls* was published.

One friend speculated at the time that our best chance to benefit from the patent would be in the unlikely event that a large company might steal our process and make money with it; then we'd be able to sue for our fair percentage of their profits. Nothing of the kind has happened, but the patent has at least given us peace of mind and credibility. And perhaps it will help us to find a person or company to produce Gourd Impressions when we retire in a few years. We want very much for it to live on.

I feel free to say, speaking as merely a technician or go-between who uses gourds to connect people with nature and history, that the pottery has a special magnetism. Parents tell us that their children argue over who gets to eat out of the gourd bowl; and they often admit that they feel strangely drawn to the dishes, too. Maybe something in our evolutionary memories— memories of prehistoric times when gourds were an essential part of life—triggers this attraction.

It pleases me to think that people will be eating from our pottery for years to come, just as our ancestors ate from actual gourds. As the twenty-first century madly rolls on, we humans are increasingly desperate to remember where we came from.

~

Pottery has become our main source of income at

The Gourd Place, accounting for 80-90% of our gross sales. So of necessity I've developed a production process to make its creation somewhat efficient.

Although I was the first to use *gourds* as molds for casting pottery—at least as far as we and the patent office can tell—we certainly weren't the first to use other kinds of molds for slip-casting. Centuries ago, human beings discovered that plaster is the perfect material for making molds, because its porosity causes it to absorb water from liquid clay.

When a plaster mold is filled with slip—for anywhere from five minutes to two hours—a semi-firm layer of clay forms and temporarily adheres to the mold, even when the still-liquid portion of the clay is emptied out. After a day or less, this clay lining is firm enough to remove from the mold. The resulting vessel retains the shape and texture of the mold.

The casting process that I use with gourd molds is much the same except that the casting requires many hours; and the clay vessel usually can't be removed from the gourd mold for at least a week.

So the key to our being able to produce enough pottery is the use of plaster molds. I make these by pouring plaster over models that are original gourd-castings; the plaster picks up every detail of the textures. I make molds for certain popular items in duplicate or triplicate so that, for example, if we run out of soup bowls—or, ideally, *before* we run out of soup bowls—

we can cast several at a time.

Typically, ten to twenty items are cast each day. These are removed from their molds the following day, trimmed, and placed on our greenware shelves to dry. Within a couple of days, these bowls, plates, or vases are dry enough to glaze.

Despite the fact—or maybe because of the fact—that the making of our pottery has become routine, we're continually trying to improve its quality. We care that, by virtue of being hand trimmed, each piece is a little bit different from the others; but we want each to meet certain standards of thickness, smoothness inside, and uniformity in the way its top edges are trimmed.

Pottery production at The Gourd Place is a group effort. Helpers Patty Workman and Tina Hartnett now do the lion's share of the casting and trimming work. These tasks, far from being purely mechanical, require special sensibilities, both technical and aesthetic.

Not only are Patty and Tina very skilled at these tasks, but both have become knowledgeable about other aspects of our production as well, including the science of maintaining the right balance of ingredients in the slip and the science of firing the pottery. When there's a kiln crisis or a slip crisis, I talk freely with them about it and benefit from the exchange. I no doubt drive them crazy by talking issues to death, but they are patient with me and increasingly engaged as time goes on.

Everyone is involved in glazing. I've always been

open about the fact that we use commercial glazes, explaining when asked that my time and energy go into developing the molds rather than mixing our own glazes. Even so, we've learned from experience how to "doctor" glazes by adding ingredients and how to layer different glazes for more interesting results than one glaze alone would create.

Another part of the process for preparing pottery to be fired is something we call "highlighting"—the coloring of outside textures with underglaze, which adds color without the glassy effect of glaze.

Whoever is staffing our retail store at any given time is usually glazing or highlighting if not helping visitors. Brushing at least three coats of glaze onto each piece of pottery is quite time-consuming.

Helpers who glaze regularly want to be able to identify their own items after they've been fired; therefore, as part of the signature, each piece bears a subtle mark that we "gourd girls" (a job title now shared with anyone who helps us in our business) can identify. Unloading a batch of beautiful pottery from the kiln is fun and rewarding for those who are responsible.

Although production pottery is our mainstay, we enjoy making some one-of-a-kind pieces that we display in a special space designated as the "Artist at Play" area. We experiment with new glazes and glaze combinations on these pieces, so it's always fun to see how they turn out. Most of the artist-at-play pieces are

cast for a short time so that their walls are thin and flexible, allowing us to change the shapes as soon as the clay is removed from the plaster molds. Therefore each "twisted piece," as we call it, is truly one of a kind.

I usually manage to have an original casting or two in that area as well. These are bowls or vases that have been cast in actual gourd molds but have not been used as models to make plaster molds; instead they're glazed and fired as one-of-a-kind pieces. We include the gourd mold, sometimes in pieces, for the purchaser as an interesting display component—and as assurance that the piece will not be reproduced.

To me, the original castings are pure magic. Their markings are unique, like human fingerprints designed by the Creative Force.

~

As a result of my work with gourd-casting, I've begun feeling compelled to reproduce other natural creations—leaves, pine cones, mushrooms, boulders (trademarked as *Bowlders*), bark—and, most recently, large bugs—by making molds and casting them in clay.

These compulsions cause me to see the natural world with fresh eyes and want to learn more about whatever the current focus is. For example, I had never been interested in mushrooms—especially because I don't like to eat them—until I started to make castings of them. Suddenly I couldn't learn enough about the various kinds of mushrooms. Moreover, seeing my

castings sometimes triggers the interest of visitors, too —in a way that seeing the real objects in nature may not. We all take the natural world for granted at times.

This drive to reproduce natural phenomena in clay seems a bit strange, even to me; but maybe it's the same urge that causes visual artists to draw and paint images from nature. Such urges seem to be a desire to capture a moment in time and space, thus making "permanent" a bit of Life Force.

As one who claims quantum physics as my religion, I should acknowledge that the desire to make *things* at all seems counter to my understanding that nothing is solid and that, as I like to put it, "matter doesn't matter." How can I reconcile what I am doing with my understanding of the subatomic world and the life lessons to be found therein?

I have to believe that we are called to play our roles on this plane, the only reality we're really capable of perceiving, as the unique individuals that we are; to interact with this world, even if it is an illusory one; and to entertain the Creative Force in ourselves even when the results might seem ludicrous or pointless.

Deny it though she might, Janice acts out her experience of the Creative Force in ways that are inspiring and never ludicrous, as mine can be. Since our business's beginnings, she has created beautiful and clever displays, first at craft fairs and later in our shops, which a surprising number of people notice and

compliment. I'm sure this seldom happens in a typical store.

As a way of displaying our Gourd Impressions vases to best advantage, Janice has taken up flower arranging. Her eye-catching and often unconventional arrangements are an inspiration to visitors. And, in recent years, she has turned our long-standing "Now in Bloom" educational wildflower exhibit into an artistic display that people enjoy and appreciate more than ever.

~

Where does all of the attention to clay leave the gourds—our original inspiration and *raison d'etre* for The Gourd Place?

With help, I'm managing to keep a few of such items as planters, carved containers, birdhouses, and kitchen utensils in the shop. Gourd night lights, toys, and ornaments come and go. I'm always torn by the need for both gourds and pottery but routinely give preference to the pottery, because I have to be pragmatic when it comes to making what's profitable.

Interestingly, Janice is more, well, *defensive* of the gourds, in the perpetual battle for my workshop time, than I am. Maybe I'm able to postpone the angst she experiences because of my hope that a new idea is coming, something that will bring the original medium back to being on an equal footing with the pottery.

For now, there would be empty display space in the gourd shop building if not for Janice's determination

to find good quality work to fill it. She has begun buying from a couple of sources.

One source is a fair trade company that sells Peruvian gourd items made by many different artists. The other is a company in the U.S. that is doing what I didn't want to do in the 1980s: making gourd items on a large scale and selling them to shops around the country. They make cute, good quality items of a kind that I've never been drawn to, such as Easter bunnies, Santas, and other holiday-themed items.

For me as of this writing, it is mostly my own long-standing Christmas ornament tradition that keeps my spark for gourd work alive. In *Gourd Girls*, I explained that, beginning the first holiday season after September 11, 2001, Janice and I had become intentional about choosing a meaningful theme to carry out each December. Every year, I make special edition gourd ornaments designed to carry out the theme.

We have continued this tradition and, while the themes and messages have undoubtedly meant more to us than to anyone else, our friends and supporters have been wonderfully receptive; many collect the special-edition ornaments. They tell us their collections are important to them, and we are grateful.

In 2016, our 40th year in business, we published a booklet called *Gourd Tidings We Bring*, in which all the various ornaments we've made since 1976 are described and pictured. As I said in the introduction to

the booklet, the act of documenting our history of ornaments and themes *might* release me from my compulsion to keep the tradition going. Time will tell.

Meanwhile, my search continues for new inspiration for other gourd projects. Like any addict, I'm always living for the next fix that the Creative Force might give me.

~

Since the publication of *Gourd Girls,* Janice and I have wondered if we'd be able to maintain the level of whimsy that was a major thread in the memoir—and that provided some needed comic relief in that story. We were young when we engineered most of the crazy events in the book, and we set a standard of foolishness for ourselves that of late has been impossible to match.

Everyone knows that whimsy—or, more to the point, the state of mind and physical energy that produce it—can't be forced. So we try to encourage the impulse in ourselves from time to time without pushing too hard, and the results are always rewarding.

In October of 2005, we staged a gourd baseball game to celebrate the release of *Gourd Girls.* Most of the sports equipment—bats, balls, gloves, and catcher's mask—were made from gourds. People seemed to enjoy this event, especially those who had not experienced our more elaborate shenanigans in the past. We served hot dogs, beer, and Cracker Jacks, the latter passed around by children carrying large gourd trays.

In September of 2006, we orchestrated an event we called a "PGA" tournament—"Putt-putt Gourders' Association," that is—and charged an entry fee to benefit the Enotah Judicial District's Court Appointed Special Advocates, a volunteer group that works to insure best outcomes for children in our court system. My dad and stepmother, Bill and Berenice Wilson, were CASA volunteers at the time, so we had a front row seat to see what great work this organization does.

In our version of putt-putt golf, balls and clubs were gourds, naturally. We had set up an elaborate course in the backyard with gourd animals, mushrooms, or flowers serving as obstacles and props. There was more breakage of balls and clubs than we had anticipated; but our friend Lee Tidmore saved the day by setting up a repair station and taping gourds together as fast as people could break them. The winning team was photographed with one member wearing a green jacket, just like in the Masters tournament.

For several years thereafter, we created special themes for our annual April re-opening of the shop. My favorite was called "Let Your Dreams Set Sail." It was a blessing of the fleet in which attendees were invited to write down a dream of theirs and place it inside one of our gourd sailboats before it was launched.

We still make and launch our gourd sailboats every year, although dealing with the occasional capsized boat or dislodged mast has become a harder

chore than it used to be. The boats have long been a symbol of the gourd life that must not go by the wayside —not only because visitors might be disappointed, but because *we* need to see them keeping our dreams afloat.

Another spring opening was themed "Life Is Gourd" as a spoof on the popular "Life Is Good" merchandise. Our characters in front of the shop were made to look like the trademark stick figures with big smiles on their round gourd faces. Throughout the day, people played gourd games we had created: hopscotch, bowling, and gourd-minton, all using gourd equipment. We even made a pool table with the regulation number of gourd balls and of course long-handled dippers as cue sticks.

One year April Fools' Day fell on a Saturday, so we seized the special opportunities that day afforded. I made a gourd telephone that rang, a gourd frog that croaked when someone walked past it, and numerous other critters and gourd-related jokes for visitors to experience throughout the day. The scene in front of the shop was of a "victim," surrounded by crime tape, who had been "gourd to death." The character was on the ground and had been pierced through the chest by a long-handled gourd. I made holes in the front and back of the fiberglass mannequin as well as its t-shirt so that the gourd actually went through the body.

The only opening day event that bombed was one that we had expected to be among the best: *Bingourd*. It

was just like a Bingo game, complete with cards spelling "BINGOURD" across the top, and the requisite number of little numbered gourd balls that were tumbled in a large gourd made for that purpose. Having conceived the idea as a fun way to raise funds for the Sautee Nacoochee Center, we sold cards and gave all the proceeds to the center—but the turnout was inexplicably and embarrassingly low. We are keeping all the parts of the game for some future use.

During several Februaries in recent years, Janice and I have held a one-day sale on pottery dated the previous year. It was a way to generate income during the lean winter months when we were (and continue to be) closed; the sale became almost like a party for our hardcore pottery fans. One year we even served champagne.

Because the sale date always fell soon after Groundhog Day, I decided to make a groundhog to photograph for our email promotions. I bought a tiny stuffed toy one, made a gourd head for it, and called our character General Beauregourd Lee as a spoof on Atlanta's groundhog, General Beauregard Lee. I had fun photographing him as he came out of his burrow every year and reporting on his predictions. He was only about five inches tall, but one couldn't tell in the photos what size he was.

Finally, Groundhog Day fell on a Saturday one year. A life-sized Beauregourd, wearing a real fur coat

and a gourdhead with groundhog ears, made an appearance at the sale that day and was photographed with visitors. Our current trend is to have our sale on reopening Saturday in April, but I do plan to bring the groundhog back, at least by email.

For the most part, our big events seem to be giving way to a greater emphasis on everyday whimsy for visitors to enjoy. The gourd cash register, for example, *never* fails to make people laugh or smile. I have recently "upgraded" it by installing a motherboard ("mother*gourd*," a customer recently quipped) into one of the drawers. So lately, after a visitor has a laugh at the register itself, we pull out the special drawer and explain that it has recently been computerized. Some people get a puzzled look and actually ask, though sheepishly, "But how does it work?" "It's wireless," Janice likes to reply.

Visitors still enjoy the photo opportunities afforded by the gourdhead masks on the porch of the gourd shop building; and children of all ages enjoy putting together the old, beat-up gourd puzzle. I tell myself that I must get around to making a new one, but my aging shoulder gives an emphatic "No!" We'll see.

Our gourd phone made for the April Fools' Day event a few years ago has recently been installed in the kitchen shop where a regular phone used to be. I left the actual ringer on the wall underneath so that if the phone rings when visitors happen to be nearby, they think the

gourd phone works.

Gourds are often called "the fools of the vegetable world." This description refers ostensibly to the fact that they aren't what they appear to be, *i.e.,* something edible. Gourds are nature's mimics and will always inspire Janice and me to use them accordingly. I see our efforts to surprise people and make them laugh as one of the most important missions of my life.

~

In recent years, our increasing need for help from other gourd girls has offered new challenges.

Liesel Potthast, our friend and helper whose "gourdination" anchored a chapter in the memoir, ended her time at The Gourd Place in 2012 after being our mainstay for ten years. She needed to explore other possibilities for her life; we completely understood, honored her decision, and wished her the best.

At the end of her last day with us in December of 2012, the three of us drank a bottle of champagne, waxed philosophical about meaning and purpose in life, and cried together. It was a bittersweet time for all of us.

So integral a part of our operation had Liesel been—and so dependent on her had I been in the workshop, particularly for the casting and trimming of the pottery—that we found it hard to imagine how we would carry on.

We had the winter of 2013, while the shop was closed, to adjust and make plans. Janice and I both tried

to see the coming spring as a fresh start, but I could only feel a deep weariness. One day as we talked about the challenges that loomed before us, I half-joked that I needed to learn how to invoke the Law of Least Effort, one of seven spiritual laws explained by Deepak Chopra in a book that we had read together many years earlier.

That phrase "Law of Least Effort" haunted me for days until I dug out Chopra's book, *The Seven Spiritual Laws of Success,* and read the chapter—dozens of times. I still read it regularly.

I'm admittedly prone to magical thinking, especially during hard times; but five years later, I still believe this natural principle rescued me and changed my life.

The components of this transformative law are acceptance, response-ability, and defenselessness. Chopra explains that most people waste actual energy fighting reality in our heads and hearts. Wholehearted acceptance of one's circumstances—or non-resistance, as some philosophers call it—is powerful when combined with a simple decision to respond to the challenges at hand as best one can and to cultivate defenselessness, thus releasing oneself from the need to be seen as being right or always on top of things.

For me there *was* magic in this simple formula and my determination to make it part of my way of being. The magic didn't happen all at once, and of course I still lose sight of it regularly. But in that winter

of 2013, I remained focused on the Law of Least Effort, took myself in hand, and thus was able to get organized in new ways in preparation for the spring.

In accordance with the principle of response-ability, I came to an understanding that I had the power to simplify our pottery-making operation. We had been making an impractical number of different items and could benefit aesthetically as well as practically by eliminating some of our molds. So I faced the hard decisions about which pieces would go and which would remain a part of our line.

Moreover, we made some improvements to our facilities and the workshop in particular. Simple actions such as replacing our old exterior basement door with a nice glass patio door—so that we could enjoy more light and the view of the pond and wildlife—were great for morale. We also improved our sink and counter set-up, so important for any operation involving clay.

Most importantly, our friend Patty Workman—an artist in her own right—who had helped us off and on for many years but not in a major role, became our new right-hand woman in that spring of 2013 and remains so today. Patty has risen to this challenge in her own unique and wonderful ways.

Several new part-time helpers joined us as well, each bringing special gifts and enthusiasm. A couple of them have come and gone since 2013, but each embraced and contributed to the gourd life in her own

way. To say that we are filled with gratitude for *all* the gourd girls, past and present, would be quite an understatement.

~

As we humans have to expect beyond midlife, Janice's and my journey is increasingly about coming to terms with change and loss—of loved ones and of our own youth—but also about regrouping, learning to celebrate new challenges, finding creative ways to shore ourselves up for what is to come.

Like most everyone reading these words, we've lost important people—people who played significant roles in *Gourd Girls*—in the last twelve years, including my beloved father, Bill Wilson; and Gloria Brown and John Kollock, both special friends and mentors who continue to influence us even in death.

In 2015, Janice's mother, Nancy Webb, had a serious stroke, an event which affected the whole family. Now almost 93, she has regained some mobility but still has to work hard at trying to overcome the weakening effects of the stroke.

We've experienced illness and decline with many precious friends as well. The spoken or unspoken consensus and instruction of all these people, dead and living, is easy to recognize and verbalize: *Keep going.* The Life Force in most of us regularly repeats those two words. What else is there?

Our own physical problems have been relatively

insignificant. Still, the most marked changes that people usually experience with aging—a lessening of physical strength and endurance—affect our ability to carry on the gourd life at what we used to consider full speed.

On the positive side of the aging column, we're seeing some pieces of a forty-something-year-old puzzle falling into place. Our marriage in 2015 was one such piece, and my entry into the club of lucky Medicare recipients in the same month was icing on the wedding cake. We paid off our mortgage in that amazing year as well.

Other puzzle pieces of our lives in recent years have been overseas trips that we wouldn't have dared hope for at the close of *Gourd Girls*. We came to the realization in 2012 that if travel was important to both of us, we'd better make a decision to get moving, no matter how tight our budget, and see what we can see of the world before we get too old or the world gets too dangerous. Nowadays, when my motivation for work starts to lag, I'm able to use travel as an incentive.

For me, the most wonderful benefit of travel has been my awakened interest in history. Both before and after a trip, I have an all-consuming desire to learn about our destination and its history. I'm well aware that travel and resources for study are privileges never to be taken for granted.

One more puzzle piece that is falling into place with the years is our increasingly strong sense of

gratitude—for one another, for friends and family, for our work, for the amazingly high standard of living that we enjoy in a beautiful and safe part of the world.

Author David Steindl-Rast said it beautifully: "The root of joy is gratefulness."

~

The subject of retirement crops up regularly these days. In early 2016, we decided at my instigation that Janice should begin a time of semi-retirement. She now keeps shop four afternoons a week and is enjoying a slower pace, although she still does errands for the business in some of her spare time. I'm thrilled that we could afford to take this step. Besides the fact that Janice is a few years older than I am, she worked many more hours in high school and college than I did. Fair is fair.

As for me, I'm not ready to retire. I'm still very much engaged in my work and also doubt that we're prepared for retirement financially. Moreover, I'm one who needs a strong central purpose. Without our business as a focus, I might sit down and never get up. My friends laugh at this statement, but I know that it's true.

In many ways—even setting the difficult question of finances aside—the challenges that self-employed people face when we think about retirement are different from those faced by people in more traditional careers.

For example, those engaged in regular careers see their paths more or less laid out from the beginning. Many know way ahead of time when they'll likely retire, and some count the days for years in advance. Even many people who love their work and strongly identify with it are conditioned to give it up at age 65 or so.

Entrepreneurs, on the other hand, have no preset structure to follow. Being independent-minded people, most of us probably don't give retirement much thought — until our friends start making the move, and then we realize how uncomfortable we are with the subject. Some of us identify so strongly with our businesses that we can't imagine who we would be without them.

Additionally, self-employed people usually have ideas and plans for future work-related projects. Retirement would mean accepting the fact that we'll never accomplish them all. About five years ago, I began making lists that I call "Things I want to do before we call it quits." A few of the ideas on the lists have been done, but new things take their places.

To state what may be obvious to most but is just becoming clear to me: Retirement is by definition a coming to terms, not only with the end of our working lives, but also with the relative unimportance of plans and projects left undone, matter how compelling they once seemed.

Once again turning to quantum physics for perspective, I remind myself that each of us is barely a

blip in the quantum field; our hopes and dreams, like beautiful soap bubbles, are easily and gracefully absorbed into the ether when the time comes.

~

In addition to our own uncertainty about retirement, Janice and I feel a responsibility toward the people who have been supporting us for forty-one years.

Some people tell us they draw inspiration from visits to The Gourd Place. Although, as I said in *Gourd Girls*, we may have pushed individuality into the realm of the ludicrous, our business does in some ways fit the stereotype of an American dream. We've definitely had to make the whole thing up as we've gone along, since there was no template for a gourd business. Even the fact that we haven't found financial success while pursuing our dream seems to allow people to identify with us in a way that they might not if we were wealthy.

There are also people who simply don't want to see us disappear because they like our products. Some are collecting sets of our dishes and ask us pointedly from time to time whether we expect to keep on for a few more years. Some locals enjoy being able to entertain their visitors by bringing them to our place from time to time. We appreciate them all.

I often wonder what we would do about The Gourd Place if, hypothetically, we suddenly became independently wealthy; we can't imagine leaving people high and dry.

It goes without saying that we would love to find the right successors, but the order is tall. First, they have to be able to buy us out, since our property and business are our "401-K." These successors, from our point of view, also have to be dreamers—and they have to believe in our nature-centered educational philosophy.

The list goes on. They have to be willing and able to learn our pottery process as well as our gourd-crafting techniques. Finally, they have to lack the desire to make large amounts of money—or, conversely, to possess the drive and business acumen to take our pottery concept to bigger audiences by manufacturing and wholesaling the products.

Janice and I can only hope we will find the right people through grace, because there's no logical means to search for the successors I've just described. Meanwhile, we'll carry on and continually give thanks for life as we know it, increasingly made possible by committed and caring gourd girls who help us keep the business going.

The future is a mystery to all of us, no matter what our circumstances. One special childhood memory Janice and I have in common is that of our mothers singing "*Que Sera, Sera*" to us. The two of us sing it together occasionally, enjoying the idea of reprising those sweet words at this time of life:

Que Sera, Sera,
Whatever will be, will be,

The future's not ours to see.
Que Sera, Sera,
What will be, will be.

Occasionally in the shop we have conversations with young people who are searching for their dreams, maybe feeling at a loss. I like to tell them that "don't know" is actually a great place to be, because it literally means dwelling in possibility. Ironically, Janice and I are now in that beautiful place called "don't know."

In the Foreword to *Gourd Girls*, I wrote that the gourd life is simply "a metaphor for the kind of life to which we aspire: one in which everyone gets to be herself or himself and to do something fulfilling." In that sense, we plan to continue living the gourd life. May it be so.

Janice and Me

My Camp Fire Girl

This piece and the next were written for this collection.

Any person who has ever met Janice Lymburner remembers her beautiful and constant smile—and it was one of the reasons I loved her at first sight at Camp Toccoa in June of 1972, although at the time I couldn't have acknowledged this amazing truth to myself.

As newly-hired director of our beloved camp outside the town of Toccoa, Georgia, Janice had called months before and invited me to be on her staff. Although I had loved working at camp under previous directors after my sophomore and junior years at Auburn University, I'd declined Janice's offer, thinking I should instead begin looking for a job right after my upcoming graduation. A liberal arts major, I had no idea what kind of job I would be seeking.

Then, a week after graduation, I had called Janice back—even though I knew staff training had already begun at camp—and asked if by chance she still needed me. I was a lost soul who suddenly wanted nothing

more than to be at Camp Toccoa. Inexplicably, Janice said yes—even though, as she told me much later, she'd already had a complete staff and was on a tight budget.

When I arrived and found her sitting alone in the dining hall, drinking coffee and writing on a yellow pad, her welcoming smile and blue eyes gave me comfort— the promise of a summer's reprieve from my angst— and, as it turned out, a home for life.

I remember that we felt an immediate connection and talked excitedly about plans for the summer. We had our love for camp in common; that, we later agreed, accounted for our instant rapport. Now we believe that we had been together in other lifetimes.

~

Janice entered this lifetime in 1946, the first child of Nancy Scott and Jim Lymburner. They lived on the outskirts of the small Michigan town of Sparta, north of Grand Rapids. There Abby and Harry Lymburner, Jim's parents, grew apples and cherries for a living.

Jim Lymburner was a dreamer who'd made his start in the nursery business and had been selling shrubbery off of the back of a truck when he and Nancy met in Slippery Rock, Pennsylvania where she was attending college.

After they married and moved to Michigan, Janice came along and became everyone's sweetheart. She was a beautiful, sparkling child who was cherished as the first grandchild of both sets of grandparents.

Soon Jim made up his mind to take his family someplace with a warm climate and start a nursery for real. Janice was two when the little family headed south, unsure of their destination. They wound up in Atlanta, where Jim began building his dream in earnest.

Lymburner's Nursery was the first of its kind in Atlanta, and it quickly began to prosper. Janice has early memories of playing at the nursery out on Buford Highway where both of her parents worked more than full time. She tight-rope-walked the irrigation pipes on the property, had her picture taken for newspaper ads, and generally relished the role of an entrepreneur-child who was lavished with love and attention.

Others came along: Jimmy, then Sandy, then Tommy. Janice was five when Jimmy was born. She immediately took on the role of second mother to him and then to all of "the kids," as she called them.

Success had its price. Jim seemingly dreamed too big, tried to grow too fast, and, unable to cope with financial difficulties, turned to alcohol; the booming business eventually collapsed and the marriage with it. Janice, sixteen by the time her parents divorced, became a strong support for her mother.

The importance of Janice's maternal grandparents in her life cannot be overestimated. This dignified couple, Betty and Thomas Verner Scott—known to their grandchildren as Grandma Betty and Grandpa T.V.— were soul mates and provided a model of a loving,

happy marriage. Janice spent much time with them throughout her childhood and young adulthood.

Janice had become a Bluebird in second grade and a Camp Fire Girl after that; therefore she'd attended the Atlanta Council of Camp Fire Girls camp for two weeks every summer starting at age eight or nine. She now cites both the year-round program and her time at camp as formative and life-giving for her. It is no wonder she still has the Camp Fire Girl mystique, as I like to call her special aura.

Perhaps both because of and in spite of her family's difficulties during her teens, Janice turned out to be an unusually responsible, hard-working, and graceful young woman. She had known since childhood that she wanted to be a teacher; in fact, as a Camp Fire Girl she chose an Indian name that meant "teacher." I still love to tease her about the name, "Wa-an-spe-kia," which sounded more like a disease than a poetic word for teacher.

Janice worked her way through Oglethorpe University, graduating in 1968 with a degree in elementary education. She began teaching that year at Kittredge Elementary School in Dekalb County and eventually taught in Dahlonega and Cleveland for seven more years before leaving the classroom to go into business with me.

In early 1972, the year I met her in the dining hall, she had been offered a summer job as camp

director. She was both thrilled and terrified to have a chance to fulfill another lifelong ambition.

The job of camp director, as one might imagine, would be challenging for any person, especially a young woman of 25, the minimum age specified in the job description. Janice had a staff of 30 college students to supervise—and 100 vulnerable young Bluebirds and Camp Fire Girls ultimately in her care.

She remembers that summer as a very stressful one, but she was very successful. She was kind but quite tough for a spindly-legged little person with such a sweet smile—a smile that kept her in the good graces of her staff even as she imposed high standards for their job performances.

The following summer of 1973, her second and last as camp director, she was even better. I was her assistant director that year and can say that she presided over what was likely the best summer the camp had ever experienced.

Today Janice is everything she was then but with a depth added by the experiences and challenges of 44 more years. The years have not changed her Camp Fire Girl mystique or her sparkle. She loves parades, pretty gift-wrappings, flowers, and fireworks; she's compelled to pick up highway litter, even at the most inconvenient times; she smiles 99 percent of the time, even when no one is looking. My love, admiration, and gratitude for her grow deeper every day.

Looking for Love
in All the Wrong Places

This piece is very personal. I have changed a few names to avoid making anyone uncomfortable.

I don't remember hearing Frank Sinatra sing "Love and Marriage" for the first time, any more than I remember hearing that loaded word *queer* for the first time. Both were commonly heard in the fifties—two sides of a coin, one might say.

I didn't start to worry about being queer myself until I fell in love with Mrs. Matthews, my seventh grade chorus teacher. She was talented, young, and pretty, and I was one of her pets. I thought about her a good deal and hung around after her class along with a couple of other students. She was enough in my thoughts that I wondered if there was something not-quite-right about it; but the full-scale worrying was still down the road.

I was a normal-enough-seeming girl with plenty of friends. Fortunately, I didn't fall in love with any of them until the tenth grade; but then I fell hard for a girl who had become my best friend. I thought about her constantly and lived for the time we spent together. Elaine was very expressive about the importance of my friendship to her, but of course she had no idea of the feelings I was experiencing.

All was good until Elaine joined a clique, as

teenage girls will do, and left me behind. I was heartbroken in the way young girls are when their boyfriends drop them. I did the regular things: cried, despaired of ever being happy again, rode by her house when I could get out in the family car by myself. Unlike other girls, I couldn't tell a soul what I was going through.

The grieving went on for at least a year. During that time, I had a boyfriend and went to dances; served on the student council; played on the tennis team; was active in my Methodist youth group; performed with friends in a folk singing trio; and even misbehaved in class as I always had. I must have appeared well-adjusted.

Then there was another me, one who closed the door to my bedroom while I played the guitar and sang Paul Simon's "I Am a Rock, I Am an Island"; who knew deep inside that something was terribly wrong with me and floated the subject of suicide inside my head; who, as a fervent believer in Jesus, prayed many times daily to be healed.

My mother had a book of advice by Eugenia Price called *Woman to Woman.* I repeatedly read part of the book in which Price addressed the topic of "inordinate affection" between women, words which reinforced my belief that I was in need of healing.

Eventually I got over Elaine, graduated from high school in 1968 with honors, and went to Auburn

University. There, a small fish in a large pond, I failed to distinguish myself as a student or otherwise. During my sophomore year, I fell in love with a girl in my dorm named Sarah even while I was wearing the lavaliere of Miles, a Phi Delta Theta boy. Like Elaine, Sarah was clearly heterosexual; and even had I thought otherwise, I'd never in a million years have confessed my feelings. I was still praying hard, but obviously not hard enough.

The heartbreak wasn't as dramatic as before. Sarah transferred to another college to be closer to her home, and we remained friends. Meanwhile, I dated boys and had crushes on a couple of girls but didn't fall hard again until my senior year.

I spent time in the psychology section of the university library looking—surreptitiously, of course—for information about homosexuality. At that time, the verdict seemed unanimous: I was sick, sick, sick. Yet the idea of psychotherapy didn't cross my mind; such a solution would have been out of the question since seeking therapy would have meant confessing to my parents.

Somewhere along the line, I became aware of the concept of the self-fulfilling prophecy; thus guilt was piled on top of worry. What if, because I so feared being queer, I was bringing the condition on myself? These thoughts further complicated an already-confused mental situation in which I tried to be in denial about my homosexuality, at least intermittently, even while I

prayed to God to change me. Cognitive dissonance reigned.

The girl I fell in love with senior year was my roommate, and, to make matters even more difficult, was quite boy-crazy. My friendships with sorority sisters in the dorm were my salvation, along with my refusal to give up on the idea that the right boy would come along.

One boy in particular whom I dated as a senior repeatedly asked me to marry him, and there was another serious relationship after that one. As much as I might have *liked* these young men, I wasn't in love with them. Maybe I hoped my feelings would change—and it was important to be able to tell my parents and grandmothers about some guy or another I was dating. People were always asking.

I constantly wondered if I was hoping for too much. "Most people probably settle," I told myself. "Maybe if I just went ahead and married some nice guy, the happy ending would fall into place." But I could see that some of my friends were actually starry-eyed, just like lovers in the movies.

At one point, I asked my mother the age-old question: "How do you know?" To her everlasting credit, she told me very clearly that I would know when the right person came along and that I definitely should not settle.

And the right person did await me, just around the corner from college graduation.

Janice and Me

This piece appeared in the White County News *a few days after Janice and I were married on September 20, 2015. I thank then-editor Billy Chism for suggesting it and having the courage to print it.*

On September 20, 1974, the world turned upside down for Janice Lymburner and me. That was the day when, after two years of friendship, we finally spoke words acknowledging who we *really* were: two people in love.

We were in shock at having made our irrevocable declarations but were given the grace to understand that love cannot be wrong. Still, there would be no engagement, no wedding, no well-wishers. Consumed with joy and anxiety in perhaps equal measures, we were far too challenged by our new situation to imagine or wish for the right to marry.

Our commitment was formed and spoken in bits and pieces as the first few years strung together. At some point, "I love you" simply became "I'm going to love you forever."

It would be eight years before we told anyone our secret. A person cannot know in advance what the closet is like, how it is to begin feeling like a stranger to one's family overnight by virtue of being unable to reveal the most important relationship of one's life. In time I came

to see the silence surrounding us as a ghetto of sorts. But we loved each other enough to live in the closet.

I was 23, Janice 27 when we got together. We lived in a basement apartment on Church Street in Cleveland. Janice taught first grade at White County Elementary that year, and I taught English at Lumpkin County High. Fellow teachers must have been puzzled by our awkward responses when they mentioned guys they wanted us to meet. We maintained our integrity by simply enduring the strange looks without making up boyfriend stories.

I soon left teaching and started a business, drawn to the idea of being independent; Janice joined me as co-owner a couple of years later. The business, now known as The Gourd Place, became our joint creation and a source of great satisfaction. And the fact that we were business partners gave people a way to relate to us without wondering about our marital status.

The years went by. We were mostly happy, but there were always times when the closet was especially painful. Weddings, for example, meant being corralled with the single women and pressed to try to catch the bride's bouquet. And Christmas meant that we had to part, each spending the holidays with our own family.

In the early to mid-eighties, as the closet became stifling for us, people's attitudes seemed to be changing ever so slightly. We eagerly devoured the occasional newspaper article or item on TV about gays and

lesbians. Finally we managed to come out to a handful of people. It was freeing but traumatic and exhausting; and each person we told was repeatedly sworn to secrecy. We still lived in fear.

And then Janice joined Nacoochee Presbyterian Church in 1990. I didn't join but often attended services with her. Although very few people there knew officially that we were a couple, many seemed to make a special effort to convey their acceptance to us. We began to feel like part of this loving community, and Janice was asked to serve in a leadership role.

After learning that church policy then excluded "self-affirming" gay and lesbian people from serving, Janice felt compelled to come out at church. I was thrilled at this turn of events, having long been ready. The two of us participated in discussions and programs as the church studied the subject of homosexuality; and although we had difficulty finding our voices after long silence, the opportunity to speak in these meetings was strangely cathartic.

Soon we came out to our surviving parents, Janice's mother and my father. There are no words for our elation at this act, which we had for so long imagined as being like death.

And now, amazing to think, twenty-something more years have gone by with a good semblance of normality in our lives. We are blessed with full lives and many friends.

We are of course aware that many people don't share our belief that love cannot be wrong; but we try to go on living our lives as best we can without dwelling on the discord. We're senior citizens now and aware that perhaps we can set an example for younger friends and detractors alike.

Elated at the recent decision of the U.S. Supreme Court giving us the legal right to marry, Janice and I made plans for a long-awaited wedding. We were treated with dignity and courtesy as we applied for a marriage license at the White County Courthouse.

On September 20, 2015, the forty-first anniversary of those long ago terrifying declarations, we were married. It was a glorious day. These famous lines from Robert Browning kept going through my head and are with me still: "Grow old along with me / The best is yet to be."

Pure Gold

The first part of this piece is taken from our memoir, Gourd Girls.
The second part was written for this collection.

After the traumatic but thrilling experience of
coming out to both my father and to Janice's mother in
February of 1992, one of the first things the two of us
wanted to do was hike to the place on Mt. Yonah where
my family had scattered my mother's ashes the previous
fall. Janice had minded the shop on that October
Saturday afternoon and had not been part of the quiet
family ritual; her absence had been painful for both of
us, and we'd wanted to go there together ever since.

For the fourteen years we'd lived in Blue Creek,
Janice and I had enjoyed our own private access to the
eastern, gently sloping side of Yonah through the back
of Clifford Campbell's pasture. We had established a
regular route that took us under the pasture fence,
through a neighbor's property, and up an old roadbed
into national forest land. There we found ourselves in a
deeply-shaded world of staid old trees and fresh-born
wildflowers, ancient boulders and newly-sprung,
dancing streams of water. It was a paradise for us,
children at heart that we were.

On a chilly, overcast afternoon in late February,
we made the familiar trek so that finally I could show
Janice the place where the ashes had been scattered. We
wanted to include Mama in our amazing experience of

136

coming out to our parents, an experience from which we were still glowing. As we headed up the mountain, I was hoping to be able to recognize the spot. The winter had been rainy and windy, and newly fallen trees had changed the landscape considerably.

We approached what I recognized as the right area, a tiny clearing between the roadbed and a pretty stretch of creek. I was startled to see that some ashes were still visible on the ground, even after four months and many rains. I pointed them out to Janice, and we stood staring open-mouthed at a small mound of gray-white dust. Suddenly we both felt my mother's presence as a flash of gold came into view atop the pillow of ashes. It was real: a gold band, my mother's wedding band.

I know that the presence of the ring can be explained in logical terms and that the way it seemed magically to appear atop the ashes was just an effect of our eyes focusing. But we chose to believe that Mama was with us in that moment and acknowledged our sacred relationship.

~

Somehow, twenty years went by. In 2012, Janice's mother, Nancy Webb, gave Janice the wedding ring Jim Lymburner had given her in 1946. It is a delicate gold band with three tiny diamonds in it. Janice was pleased to have the ring and began wearing it on her right hand, as I had been wearing my mother's ring that

had come to me on the mountain.

Three more years went by, and then a dream came true. In June of 2015, the U.S. Supreme Court announced the decision that legalized same-sex marriage nationwide. After our first few days of euphoria, Janice and I cautiously began the conversation about our marriage.

"Cautiously" because, although there was no question about our commitment to one another, there were numerous other tough questions. First on the list: Now that we finally had the right to marry, did we really have the energy and inclination to plan and carry out a wedding and reception during an already busy time in our lives? Or did we want to have a simple, private ceremony?

After a week or so, we decided that it mattered to our long-supportive community as well as to ourselves that we have a wedding. But where would we hold the event, and what would the ceremony be like? How much money would we spend on the party? The two of us were known for long-standing differences both in our religious beliefs and in our approaches to spending. We jokingly told friends that divorce might precede marriage for us because of our inability to agree on wedding plans.

In reality, we didn't argue; although we joked in public, in private each of us was intent on taking care of the other by avoiding discussions that might burst our

bubble—which did stay intact despite the hard decisions awaiting us. And so for a time we were radiant, but paralyzed.

Then the rings opened the way. "What will we do about rings?" Janice asked me one evening as we danced around the subject of wedding plans.

Each of us had given the other a ring in our early years together, but we had worn these on our little fingers rather than our ring fingers. We had wanted to express the uniqueness of our relationship and avoid copying the symbolism of marriage—an institution we'd claimed to have little use for, given the fact that we were excluded from it.

Now, if we were to be married, we assumed we would exchange rings the traditional way. Janice had an idea: "What do you think about giving each other our mothers' rings?" she asked tentatively.

On the inside I felt the slightest reluctance, only because of my attachment to Mama's ring and the way it had come to me; but I didn't show it. I replied truthfully that it was a beautiful idea.

We didn't hesitate. The very next day, we took the rings to a jeweler to have them fitted to their future owners. Janice's ring was too small for me, and mine too large for her; but there was *exactly* enough extra gold in one to enlarge the other. We were all smiles and satisfaction.

That decision made, the rest began to fall into

place. Each of us happily made compromises on the content of the service and the particulars of the reception. We agreed not to obsess about clothes but just to find something casual and comfortable. When the day finally came, all went beautifully.

Weeks later, we admitted to one another that giving up our mothers' rings had been hard; the individual histories they represented were precious to each of us. But we relearned one of life's most important lessons on our wedding day: that letting go, not hanging on, is the way we grow—even after 41 years together.

The End—or the Beginning?

I wrote this in October of 1992, the year my father and step-mother, Bill and Berenice Wilson, moved to White County as newlyweds. I wasn't consciously thinking of Daddy's new beginning when I wrote the piece, but he cried when he read it. Now I'm a newlywed of sorts and old enough to identify with it myself.

I have fallen victim to a case of seasonal dyslexia. Sitting outside on the small deck that overlooks our pond, I'm realizing that, except for the colors of the leaves around me, I can't distinguish this October morning from a spring one. Are we finishing or starting?

There's a mysterious feeling of expectancy in the air. Bluebirds are going in and out of their nesting boxes as if making plans to start new families. What can they be thinking?

A minute ago, as my eyes and brain struggled to coordinate with one another and make sense of the blinding sparkles on our pond, a flock of geese rose all at once in a watery flash and took my breath away. In an instant, they were out of sight. It could be spring or fall; the geese could be coming or going. They know which, but I'm not sure I do.

And the insect noises! They could be tuning-up sounds or tuning-down sounds. If I closed my eyes and listened intently—and if I didn't know the date on the calendar—would I be hearing swan songs or birth announcements? I suspect they're much the same.

141

Maybe we humans have these occasional episodes of seasonal dyslexia to teach us that beginnings and endings *are* much the same and that we go from one to the other in a twinkling. We are, after all, mostly just water and sparkles; and, like the geese I saw this morning, each of us will one day depart in a flash and be off to points unknown, finishing—and starting.

Photo by Becky Portwood

Priscilla (left) and Janice (right) on their wedding day.

CPSIA information can be obtained
at www.ICGtesting.com
Printed in the USA
FSOW04n0005120317
31665FS

9 780692 855614